Wyndham Lewis

THE PROFILES IN LITERATURE SERIES

GENERAL EDITOR: B. C. SOUTHAM, M.A., B.LITT. (OXON.)
Formerly Department of English, Westfield College, University of London

Volumes in this series include

Wyndham Lewis

William Pritchard

Professor of English
Amherst College, Massachusetts

LONDON
ROUTLEDGE & KEGAN PAUL

First published 1972
by Routledge & Kegan Paul Ltd
Broadway House, 68-74 Carter Lane,
London EC4V 5EL
Printed in Great Britain by
Northumberland Press Ltd,
Gateshead
© William Pritchard 1972

ISBN 0 7100 7186 8

The Profiles in Literature Series

This series is designed to provide the student of literature and the general reader with a brief and helpful introduction to the major novelists and prose writers in English, American and foreign literature.

Each volume will provide an account of an individual author's writing career and works, through a series of carefully chosen extracts illustrating the major aspects of the author's art. These extracts are accompanied by commentary and analysis, drawing attention to particular features of the style and treatment. There is no pretence, of course, that a study of extracts can give a sense of the works as a whole, but this selective approach enables the reader to focus his attention upon specific features, and to be informed in his approach by experienced critics and scholars who are contributing to the series.

The volumes will provide a particularly helpful and practical form of introduction to writers whose works are extensive or which present special problems for the modern reader, who can then proceed with a sense of his bearings and an informed eye for the writer's art.

An important feature of these books is the extensive reference list of the author's works and the descriptive list of the most useful biographies, commentaries and critical studies.

<div align="right">B.C.S.</div>

Contents

CONTENTS

Acknowledgments

The author and publishers would like to thank the following for permission to reproduce copyright material:

Calder and Boyars Ltd; Extracts from *The Letters of Wyndham Lewis*, ed. William Rose and Mrs Wyndham Lewis, and *One-Way Song*, Wyndham Lewis, by courtesy of Methuen and Co. Ltd; New English Library; Russell and Russell for extracts from *Men Without Art* [1934], New York: Russell and Russell, 1964; The Regents of the University of California for material originally published by the University of California Press; Mrs Wyndham Lewis; Syndication International; Extracts from *Wyndham Lewis on Art*, ed. Walter Michel and C. J. Fox, Copyright 1969 by Mrs Wyndham Lewis, Walter Michel and C. J. Fox, reprinted by permission of Funk & Wagnalls, publisher.

Introduction

Wyndham Lewis is often spoken of in the same sentence as T. S. Eliot, James Joyce and Ezra Pound, usually at the end of it—'and Wyndham Lewis'. It is not always clear that the writer of any such sentence has had much acquaintance with the books Lewis wrote. In fact Lewis wrote over forty books on far-ranging subjects and in various forms: novels, short stories, poetry, a play, sociological and cultural analysis, philosophical, literary and art criticism, polemic, memoir, travel, and many more. Most of these books are unfortunately out of print today but this need not deter someone curious to read an extraordinarily gifted writer of masterly significance. Throughout this introduction to his works we will avoid treating him as primarily a novelist, or as primarily anything, since his reputation should be understood in terms like the one he proposed by suggesting the phrase 'portmanteau man' to describe himself. Lewis always asks us to be interested in more than one department of human affairs: in art *and* politics, philosophy, history. He also asks us to respond to his writings with as much wit and liveliness as we possess; for only through the reader's active engagement can anything come of picking up one of his books.

A few biographical facts will be mentioned, though the best way to get a sense of his life is to read through the

late W. K. Rose's fine selection of Lewis's letters. Percy Wyndham Lewis (he dropped the Percy later on) was born in 1882 on his father's yacht near Amherst, Nova Scotia. His father was American, his mother English; they separated early in Lewis's life and he was sent to Rugby and then to the Slade School of Art. He spent the early years of this century living and painting in Paris, then returned to England in 1909, published some stories in Ford Madox Ford's *English Review* and met Ezra Pound. With Pound he founded *Blast* for the purpose of hailing and furthering what he called the Vorticist revolution in art, or putting it another way, to hail and further the kind of art he and others were producing in their paintings and sculpture, and to a lesser extent in literature. At about this time he wrote *Tarr*, his first genuinely creative novel (he had done a potboiler previously but could not get it published), then entered military service and was trained as a gunner and bombardier. *Tarr* was eventually published in 1918 by the Egoist Press which also published Joyce's *Portrait of the Artist*, and Eliot's and Pound's poetry. During the 1920s Lewis's ambitions as a writer broadened to include the state of European culture and politics; he wrote a number of books of which *The Art of Being Ruled* and *Time and Western Man* are the most famous works of criticism, and *The Apes of God* the most noted novel. He went on during the 1930s to write what seems to me his best fiction and to engage in many literary and non-literary controversies involving figures all the way from Winston Churchill to Dame Edith Sitwell. At the outset of the Second World War he and his wife sailed for North America where they lived mostly in Canada and where Lewis painted a number of portraits, and lectured and taught at universities. He returned to England at the close of the war, wrote more books and had a retrospective

exhibition of his paintings at the Tate in 1956. He was art critic for *The Listener* until his eyesight failed in 1953. But he continued to write his final books and was working on a new one when he died in 1957.

I am convinced that the best way to go about getting in touch with Lewis's writings is by exposing oneself to them rather than by being told that his importance was of this and that sort, or that his place in English literature was thus and so. In point of fact there is at the present time no general agreement on just what his place is in any hierarchy or organization of writers: if this is partly due to the fact that he is not widely read and known, it is also because he produced a large, difficult body of writing that refuses to be fixed into neatly drawn categories. Consider, for example, the relative ease with which E. M. Forster's work can be disposed and laid out, or even that of a bulkier more troublesome writer like D. H. Lawrence. My own exposure to Lewis occurred when I was preparing for some examinations in graduate school and found his name on a Tutorial Bibliography along with Norman Douglas, Max Beerbohm and others. *Tarr* was recommended, so I took it out of the library, read a few pages and thought, this is a very strange book indeed. At which point I did not plunge on but did eventually come back for another attack, that time successful. For the last fifteen years I have been reading and re-reading Lewis with pretty much unflagging interest; the selections to come represent my attempt to interest others in one whom I think it is still fair to call a virtually unread author.

Scheme of extracts

The extracts are held together by a single common quality: the presence in each of them of Lewis as a performing artist. Whether the particular book from which the passage is extracted should be termed a novel, a memoir, a piece of literary, political or social criticism or a polemic is less important than the fact that if we read and listen well we must respond to a highly energized and unmistakably original use of language. Whatever 'point' Lewis is making, he makes it through a medium which strongly compels our attention. If there is instruction, it begins in delight, even though delight might seem too delicate a word to apply to the often harsh surface of his prose.

There is no point in worrying much about chronology; rather the extracts have been chosen for their individual charm and power, and for the way that, juxtaposed with other passages, they will be found mutually illuminating. But the main hope is that they will sufficiently engage the curiosity of those who have not read Lewis's works —and there are many such—to take some steps towards rectifying the omission. As D. H. Lawrence, hardly Lewis's favourite writer, was fond of saying: 'If it isn't any fun don't do it.' Lewis's own sense of fun was supremely evident, and he asks his readers to respond to it with whatever individual talents they possess in that regard.

Character as performance

'The root of the Comic is to be sought in the sensations resulting from the observations of a *thing* behaving like a person. But from that point of view all men are necessarily comic: for they are all *things*, or physical bodies, behaving as persons.' This formulation from Lewis's essay 'The Meaning of the Wild Body' is a fair rationalization of the way his early novels and short stories went about the business of creating a 'character'. In this sentence he invokes 'the root of the Comic'; elsewhere he calls that root 'Satire' but is at pains to insist that the satire is 'metaphysical' rather than moral. In his collection of stories entitled *The Wild Body* Lewis included an essay 'Inferior Religions' which would act as explanation and defence of his comic or satiric practices. The interesting thing to notice is how the defence is carried out, as in the following passage:

I

I would present these puppets, then, as carefully selected specimens of religious fanaticism. With their attendant objects or fetishes they live and have a regular food and vitality. They are not creations but puppets. You can be as exterior to them, and live their life as little, as the show-

man grasping from beneath and working about a Polichinelle. They are only shadows of energy, not living beings. Their mechanism is a logical structure and they are nothing but that.

Boswell's Johnson, Mr. Veneering, Malvolio, Bouvard and Pecuchet, the 'commissaire' in *Crime and Punishment*, do not live; they are congealed and frozen into logic, and an exuberant hysterical truth. They transcend life and are complete cyphers, but they are monuments of dead imperfections. Their only significance is their egoism. So the great intuitive figures of creations live with the universal egoism of the poet. This 'Realism' is satire. Satire is the great Heaven of Ideas, where you meet the titans of red laughter; it is just below intuition, and life charged with black illusion.

The Wild Body, 'Inferior Religions'

Boswell, Dickens, Shakespeare, Flaubert and Dostoevsky all created 'characters' (from Dr Johnson to the commissioner) who are not alive, whose mechanism is a logical structure, who are puppets to be worked, or complete cyphers, or exuberant hysterical truths. But there is also the sense in which no literary creation, no 'character' is alive, since whether you label it 'creation' or 'puppet' it must be made out of words put down in sentences on the page which do not breathe or eat, live or die. Would Hamlet as opposed to Malvolio, Pip as opposed to Mr Veneering, be considered alive rather than dead? We cannot answer for Lewis since he did not put the question to himself in this essay, though he dealt with it throughout his life as a novelist. With respect to the passage quoted above, notice that the reader is expected to agree with what he is being told about how 'the great intuitive figures of creations' behave. Rather than carefully and soberly making distinctions between these intuitive figures and other

ones perhaps less intuitive, Lewis announces grandly that ' "Realism" is satire', throws out some colourfully opaque pronouncements about a Heaven of Ideas, titans of red laughter, black illusion, then breaks the text and proceeds to a new section. In other words, Lewis is himself a show-man in the very passage where he describes how a show-man manipulates his puppets: the 'truth' of what this passage tells us is as exuberant and, when the titans of red laughter get introduced, as hysterical as 'the universal ego-ism of the poet' demands. And it is not of much interest or value to 'disagree' with that egoism.

Here is an example from his first novel, *Tarr*, of how a minor puppet looks and behaves. Early in the book its hero, a young English painter living in Paris named Fre-derick Tarr, meets a fellow countryman, also a painter just back from a visit to Cambridge:

2

But for Hobson's outfit Tarr had the most elaborate con-tempt. This was Alan Hobson's outfit: a Cambridge cut disfigured his originally manly and melodramatic form. His father was said to be a wealthy merchant somewhere in Egypt. Very athletic, his dark and cavernous features had been constructed by nature as a lurking-place for villainies and passions: but Hobson had double-crossed his rascally sinuous body. He slouched and ambled along, neglecting his muscles: and his full-blooded blackguard's counten-ance attempted to portray delicacies of common sense and gossamer-like backslidings into the inane that would have puzzled any analyst unacquainted with his peculiar train-ing. Occasionally he would exploit his criminal appear-ance and blacksmith's muscles for a short time, however: and his strong piercing laugh threw ABC waitresses into confusion. The art-touch, the Bloomsbury technique, was

7

very noticeable. Hobson's Harris tweeds were shabby, from beneath his dejected jacket emerged a pendant seat, his massive shoes were hooded by superfluous inches of his trousers: a hat suggesting that his ancestors had been Plainsmen or some rough sunny folk shaded unnecessarily his countenance, already far from open.

Tarr, part 1, ch. 1 (revised ed., 1928)

If Tarr has 'elaborate contempt' for Hobson's arty dress, it is Lewis's task to elaborate that contempt into a verbal expression; so it is confided to us, as if it were matter-of-fact, that this athletic fellow has 'double-crossed' his 'manly and melodramatic form' by wearing a cut that 'disfigured' it, a jacket that is 'dejected', shoes 'hooded' by superfluous inches of trousers. And finally the hat: some writers would consider it adequate to strike off its affectation by invoking Plainsmen or 'rough sunny folk' (whoever they may be) as incongruously brought to mind; Lewis does that, but goes on to add that the hat is not only incongruous but really unnecessary, since Hobson's countenance ('constructed by nature as a lurking-place for villainies and passions') is 'already far from open'. However much Hobson may be typical of 'the art-touch' there can never be another artist exactly like him because his creator has spent so much superfluous verbal energy in fixing him up literally from head to toe. When Ezra Pound reviewed *Tarr* in 1918 he spoke of Lewis's 'highly energized writing', and to read that writing we have to become highly energized ourselves, participating in the animated performances of words in sentences strung together by a narrator who pretends to have no special designs on us or on his subjects. It is just the way things are, no more no less.

In this world a place, as well as a character, can render itself through animated performance; early in the novel

Otto Kreisler, a violent German who shares the main stage with Tarr and whose career eventually ends in disaster and suicide, goes to have lunch at a restaurant which behaves like this:

3

The Restaurant Vallet, like many of its neighbours, had been originally a clean tranquil little creamery, consisting of a small shop a few feet either way. Then one after another its customers had lost their reserve: they had asked, in addition to their daily glass of milk, for côtes de pré salé and similar massive nourishment, which the decent little business at first supplied with timid protest. But perpetual scenes of unbridled voracity, semesters of compliance with the most brutal appetites of man, gradually brought about a change in its character; it became frankly a place where the most full-blooded palate might be satisfied. As trade grew the small business had burrowed backwards into the ramshackle house: bursting through walls and partitions, flinging down doors, it discovered many dingy rooms in the interior that it hurriedly packed with serried cohorts of eaters. It had driven out terrified families, had hemmed the apoplectic concierge in her 'loge', it had broken out on to the court at the back in shed-like structures: and in the musty bowels of the house it had established a broiling luridly roaring den, inhabited by a fierce band of slatternly savages. The chef's wife sat at a desk immediately fronting the entrance door: when a diner had finished, adding up the bill himself upon a printed slip of paper, he paid at the desk on his way out.

Tarr, part 2, ch. 5

Compare Dickens's presentation of the top of Todgers's, in *Martin Chuzzlewit*:

The top of the house was worthy of notice. There was a sort of terrace on the roof, with posts and fragments of rotten lines, once intended to dry clothes upon; and there were two or three tea-chests out there, full of earth, with forgotten plants in them, like old walking-sticks. Whoever climbed to this observatory, was stunned at first from having knocked his head against the little door in coming out; and after that, was for the moment choked from having looked, perforce, straight down the kitchen chimney; but these two stages over, there were things to gaze at from the top of Todgers's, well worth your seeing too. For first and foremost, if the day were bright, you observed upon the housetops, stretching far away, a long dark path: the shadow of the Monument: and turning round, the tall original was close beside you, with every hair erect upon his golden head, as if the doings of the city frightened him. Then there were steeples, towers, belfries, shining vanes, and masts of ships: a very forest. Gables, housetops, garret-windows, wilderness upon wilderness. Smoke and noise enough for all the world at once.

After the first glance, there were slight features in the midst of this crowd of objects, which sprung out from the mass without any reason, as it were; and took hold of the attention whether the spectator would or no. Thus, the revolving chimney-pots on one great stack of buildings seemed to be turning gravely to each other every now and then, and whispering the result of their separate observation of what was going on below. Others, of a crook-backed shape, appeared to be maliciously holding themselves askew, that they might shut the prospect out and baffle Todgers's....

Dickens goes on for pages about Todgers's, and his pre-

sentation is more extendedly inventive than Lewis's, but the passages share a creative gusto with which inanimate things are animated. In both the pretence is, as with the presentation of Hobson, that this is simply the way the Restaurant Vallet or Todgers's appear to any dispassionate observer interested in having a look. So that to speak as Lewis does of the small business driving out terrified families, hemming in an apoplectic concierge, establishing a 'broiling luridly roaring den, inhabited by a fierce band of slatternly savages' is to speak, as it were, no more than the truth; and as if to substantiate that illusion Lewis concludes his description of the restaurant by simply informing us where the chef's wife sits and how the diner pays his bill on the way out—no tricks there.

Remembering Lewis's statement that 'The root of the Comic is to be sought in the sensations resulting from the observations of a *thing* behaving like a person', we note that these sensations can be conveyed in various narrative ways, in various tones of voice, through vastly different performances. Thus far the passages considered have featured the deadpan fully-controlled observation of things—English painters or French restaurants—behaving like a person: the Restaurant Vallet pushes people around, terrifies concierges; Hobson, actually a thing built out of massive shoes and superfluous inches of trousers, pretends that he is a rather splendid human being.

But now consider the following paragraphs, taken from one of Lewis's stories in *The Wild Body*, about a wild body, a thing that behaves like a person and answers to the name of Bestre. The narrator, an 'I' introduced to us earlier as Ker-Orr, himself 'a large blond clown, ever so vaguely reminiscent (in person) of William Blake, and some great American boxer whose name I forget' whose body is 'large, white and savage' but whose 'fierceness has

become transformed into *laughter*'—this narrator confronts Bestre:

4

His very large eyeballs, the small saffron ocellation in their centre, the tiny spot through which light entered the obese wilderness of his body; his bronzed bovine arms, swollen handles for a variety of indolent little ingenuities; his infuriated digestive case, lent their combined expressiveness to say these things; with every tart and biting condiment that eye-fluid, flaunting of fatness (the well-filled), the insult of the comic, implications of indecency, could provide. Every variety of bottom-tapping resounded from his dumb bulk. His tongue stuck out, his lips eructated with the incredible indecorum that appears to be the monopoly of liquids, his brown arms were for the moment genitals, snakes in one massive twist beneath his mamillary slabs, gently riding on a pancreatic swell, each hair on his oil-bearing skin contributing its message of porcine affront.

Taken fairly in the chest by this magnetic attack, I wavered. Turning the house corner it was like confronting a hard meaty gust. But I perceived that the central gyroduct passed a few feet clear of me. Turning my back, arching it a little, perhaps, I was just in time to receive on the boko a parting volley from the female figure of the obscure encounter, before she disappeared behind a rock which brought Kermanac to a close on this side of the port. She was evidently replying to Bestre. It was the rash grating philippic of a battered cat, limping into safety. At the moment that she vanished behind the boulder, Bestre must have vanished too, for a moment later the quay was empty. On researching the door into which he had sunk, plump and slick as into a stage trap, there he was inside—this grease-bred old mammifer—his

tufted vertex charging about the plant ceiling—generally ricochetting like a dripping sturgeon in a boat's bottom —arms warm brown, ju-jitsu of his guts, tan canvas shoes and trousers rippling in ribbed planes as he darted about —with a filthy snicker for the scuttling female, and a stark cock of the eye for an unknown figure miles to his right: he filled this short tunnel with clever parabolas and vortices, little neat stutterings of triumph, goggle-eyed hypnotisms, in retrospect, for his hearers.

The Wild Body, 'Bestre'

This portrait of Bestre is painted in harsh and flaunting language by a writer who was also a superb painter of portraits. When Lewis died in 1957 he was working on a novel never completed, to be called *Twentieth Century Palette*; and in his best novel, *The Revenge for Love* (1937), we are allowed a glimpse of the hero trying to paint a passable picture by improving his palette:

The subject was a still-life. It was a selection of yesterday's debris upon the domestic table—two empty Watney bottles, a tobacco pouch in oilskin, three mystery novels, a cutty pipe and a blue handkerchief. He did it as a red monochrome. He chopped it all up into big and little blocks of heavy red.

They all moved upon a small fork of yellow, as upon a pivot, in the left-hand corner—away off to the right, in a Noah's Ark herd. He peppered the left-hand of the system of red blocks with a shower of ash-grey flakes—a jagged confetti. Braque would have built it twice as well. There was too much confetti. But it was a muddy red: Victor Stamp *had* mastered his desire to turn it into orangeade and strawberry-cream. He had allowed nothing on his palette that would make his favourite milk-pink punch.

In the portrait of Bestre we see Lewis strenuously avoiding

13

anything like a milk-pink punch; his twentieth-century palette must be capable of supporting 'the insult of the comic', the wild body named Bestre. Brown arms must be seen in the dynamic expressiveness of the moment when they become 'genitals, snakes in one massive twist beneath his mamillary slabs, gently riding on a pancreatic swell'. The portrait would perhaps be titled 'Porcine Affront' or 'Hard Meaty Gust'; and when Lewis in the second paragraph, has Bestre fill 'this short tunnel with clever parabolas and vortices' he is alluding, consciously or not, to a favourite art-movement started by none other than himself—the Vorticist Revolution. But it is important to see that for all Bestre's porcine affront, for all the 'incredible indecorum' with which his lips eructate, we are asked to respond to him or it with relish rather than disgust. As can be seen from reading the stories in *The Wild Body*, and by comparing the portraits of these half-savage figures (called Bretons or 'Poles' or cornacs) with the civilized English painters that trip their useless way through the pages of *Tarr*, Lewis was deeply attracted to the likes of Bestre, contradicting as he did by his very existence the pallidness of kindly English humour. So that we are in effect asked to cherish each hair on Bestre's 'oil-bearing skin' mainly because it is unlike our own, though Lewis usually resists the temptation to sentimentalize these primitives by keeping his palette strong and muddy, his lines of force vigorous and unmistakable.

Sometimes perhaps too vigorous. There is the possibility that such 'highly energized writing' (in Pound's phrase) can become over-enamoured of its own muscle and one might even ponder whether, having encountered Bestre once, a reader would wish to come back to the passage very many times. Once Bestre is unmistakably captured in Lewis's brilliant prose there does not seem to be much

more to do with him: we would not expect, upon future re-readings, to learn more about him or about ourselves. Moreover there are times when the porcine affront of some Lewisian wild body is truly an affront, where the balance seems to tip towards disgust at things behaving as persons rather than delight in the 'insult of the comic' they embody. The following paragraphs occur in the work which brought to completion certain tendencies of Lewis's early satiric style. Here is Julius Ratner, one of the apes of God, slowly rising in the morning:

5

And now the morning eye-glue of yellow-lidded, sleek-necked Joo, was attacked by the tear-glands which he had. This was but a desiccated trickle because Joo was a parched wilderness of an organism so much more colloid than aquatic. But still a few gouts gushed in the yellow rock and his mouth held that taste of dry decay that was the invariable accompaniment for Ratner of waking, presage of the disappointments of a gastric order ensuing upon the coffee....

Sluggishly the clothes were urged down—Ratner crawled out. In skimpy pyjamas, of a quadrated pattern, so close-fitting as to look like tartan trews—a small yellow figure, thick-necked, grown fattish in the middle, Joo sat scratching his head. The legs—flat like fishes in the direction of their movement—spread now at right angles on the ridge of the mattress. His feet were planted in the nap of the mosque-arch of his namazlich. The imitation of the compass used to ascertain the direction of the prophetic shrine was swivelled so as to place the holy city at Moscow instead of Mecca—an accident this with gentleman-Joo.

Ratner went to the hot water can, he jadedly poured out the water, frowning at the steam, scratching his neck.

He slid his hands into the water. He soaped the channel between the muscles of the back of the neck, a hand limply hooked, with a row of four fingertips. The head moved upon its atlas, rubbing itself cat-like against the almost stationary fingers. Travelling forward over the occipital bones pimples were encountered. Working the antagonistic muscles framing the thyroid shields, he gently and limply rocked his headpiece.

With a thick glass bottle containing a substance resembling vaseline, Joo prepared to dress his scanty hair. Altaean Balm, the name of this material, was applied here and there over the scalp 'well rubbed-in'. The royal arms surmounted the title upon the label. How disgusting: 'flesh is filthy!' was his vindictive comment as the heat from the scalp entered his fingers. Then over the temporal bones his eyes and fingertips went searching for whiteness.

The Apes of God, part 5, 'The Split-Man'

And on it goes in this vein: 'Upon the hard lines of pain, the age-indexes, nostril to mouth, the constriction of the damp surface, the filling up of all hollows by that foul yellow suet (the result of haemorrhoidal trouble, and cheap mass-production intestines he was fond of reflecting with sharp-thoughted Schadenfreude) he fixed a steely, glittering eye.' Lewis's own eye, in these passages introducing Ratner, is steely indeed, wholly intent upon rendering— down to the last bit of foul yellow suet and encountered pimples—the unpleasantness of things behaving as persons. Ratner's own comment—'How disgusting: "flesh is filthy"'—seems rather close to what the reader is being asked to feel. It may well be that Lewis is parodying Joyce in these passages, his feeling about *Ulysses* being that it was 'the very nightmare of the naturalistic method' and that it swamps us in a glut of rubbishy matter. Ratner is often referred to as 'jimmyjulius' or 'jimmyjoo', a way of linking 'Joyce' and 'Jew' together in a context where

neither name gets much sympathy. But parody or no, the creation seems a good deal less genial and breezy than the way Hobson, for example, was given us in the earlier passage. Lewis is rubbing Ratner's and our noses in it, 'it' being a medium characterized by a thick glass bottle containing 'a substance resembling vaseline'.

After *The Apes of God* Lewis's style became more relaxed, offhand and often colloquially intimate. In particular the novels written in the 1930s often set up an arm-around-the-reader's shoulder relationship, assuring him that any fellow with an ordinary sense of humour would perceive, as he does, the outrageous way things behave as people. With an 'I' for narrator—in the following excerpt a preposterous writer named Sir Michael Kell-Imrie, commonly known as Snooty Baronet—Lewis pulls out all the stops, as if his own prose must be adequately outrageous to its subject, in this case Snooty's literary agent, Humphrey Cooper Carter:

6

When I look at Humph's chin I am reminded of a strong-box. The chap is all chin. I hate this face more than I hate my own, which is saying a good deal. I disliked it from the start, a long time ago.

As a box, supposing the thing were that, it would as a matter of course be fitted with a false bottom. It is not a straightforward chin. If you opened it up (touching a spring, and removing the lower jaw, with its snow-white, well-stocked dentistry and well-upholstered coral gums) you would detect that the spacious cavity did not represent *all* of the chin. The box would not be as deep as you had expected, that is not *quite* so deep. There would be a half-inch of draughtage missing, to be accounted for somehow. The hollow would be short weight.

If faces were made of wood (Humph's is a sculptured figurehead with best pouter gardee-bust, protruded forward at the attention, at the wooden salute) then the spring-worked *cache* at the bottom would be used by this idiot for carrying dispatches, of that I'd stake my life....

As for chins, I confess I am in no position to talk. I have enough and to spare myself of that. My life-long I have suffered on account of it. My teeth are so substantial, that is the fact, that the chin to go with them has to be of a solid make. But I am not in Humph's class.

Humph's head is an outsize article altogether—he is a lad that must give the hatter some mad moments, first and last. But that is nothing, what is important is that Humph is absolutely like a big carnival doll—all costard and trunk, no legs to speak of. With a portentous wooden head-piece, varnished a ruddy military pin-and-tan (Brigade of Guards), the fellow trots in. Standing to attention he stares out blankly at you: to command or to receive orders. He has been given a pair of brown eyes, why I don't know. His brow is one of those meaningless expanses of tanned wood, it slopes back a little, *brownly* flushed (he flushes *tan*).

Captain Humphrey Cooper Carter enters a room with his sturdy little legs flexed at the knees, under the weight of his torso and block. But the animal moves quickly! He covers the ground there's no mistake—almost at a scuttle. Then he draws himself up short, with a military jerk. How well I see him, in my mind's eye—halted, or set in motion, with a pointless suddenness. Lousy little automaton! I stomach the chap with difficulty really! Little low-down knees bending with a *taken-short look* that he has—how I object to that well-drilled, semi-legless body. He is just Doctor Fell—except I know to a nicety *why*.

So I ask you to picture my literary-agent—he hurries here and there in a spate of unnecessary rushes—a put-on-impulsiveness in fact—catching his face up as he whisks

round as a dog does its tail—fixing you full-face, half-about-turning, with parade-ground precision: or out of his dog-eyes of desolate blank brown he looks at you as if to say—'Yes I know I am not real!' Of course he is not. HUMPH is not real....

Snooty Baronet, 3 'Humph'

There is a sort of 'Can you top this' atmosphere about the whole passage, as we wonder what new trick Snooty-Lewis can invent to have Humph's chin or head perform next. And after all, Snooty admits he's no one to talk; he's got a big chin himself, but compared to Humph—! If in an exasperated moment Snooty descends to name-calling ('Lousy little automaton!') it's only after he has paid a full prose tribute to the 'spacious cavity' that is Humph's chin or the 'portentous wooden head-piece' to which that chin is attached. Snooty goes on to confess that he is not very real himself, but again in comparison with Humph he loses the contest.

The comic possibilities of this kind of writing are broad enough to include jokes, wisecracks, puns, name-calling, and other not very highminded verbal behaviour, while the reader is extremely aware that he is being entertained by a resourceful performer who will stop at nothing in order to keep the show going. Once the literary agent is introduced as a puppet, what then can be done with him? Well, suppose the puppet attempted to speak: what would he sound like, what would he say? Snooty has an appointment to talk business with his agent; when he arrives at the office Humph is busy, but explains himself this way:

7

'Hal-lo!' he explained hurriedly and shortly under his breath, meeting me at the door, staring at me in a great wooden unsmiling blankness, grasping my right hand just as it was escaping into a pocket. 'I say, I hope you don't mind, I've got *some*.'

He'd *got some*—he'd got *some tea*—he'd got some sardines—he'd got *some* at all events—his wide-open eye fixed itself blankly upon my face, as he stopped at his *some*.

'I hope you don't mind I've got some'—again he stopped, at what he had got—he allowed his voice to tail away at 'some', to sink with discouragement until it was lost at our feet. Then cautiously he looked back over his shoulder, into the room, with puzzled hesitation. 'I've got some people!'—All I've got is *pee-ple*, in mournful surprise he told me, dropping his voice still lower at *people*. 'I've got some *peeeep*-ple here!' he whispered rapidly. Then he added hastily. 'But they won't be here long. Do you mind? I'll get rid of them at once! Do you mind?'

Snooty Baronet, ʒ 'Humph'

People don't really talk this way do they? But Humph does, and we watch him go through the motions until eventually the meaningless banal truth 'I've got some peeeep-ple here!' is blurted out. The slow-motion take, the filling in of possibilities for 'some' (some tea, some sardines, at all events *some*), the elaborate indications of Humph's look and voice ('Puzzled hesitation', 'mournful surprise') convince us that it might have come out of a W. C. Fields or Marx Brothers comedy. Lewis is not interested in attempting to catch and render the rhythms of a living human voice; another of his favourite tricks is to set up a conversation in which each of the participants say, with

minute variations, the same thing back and forth to one another for at least a page or two. Again we are clear that this cannot be the way people *we* know talk—until we overhear a bit of conversation which sounds as if it were taken out of a Lewis novel. At any rate, extreme stylization of conversation rather than naturalistic fidelity to it would be the likely technique of a writer convinced that the world was mostly composed of things behaving as persons.

Some readers have felt that this is a degrading way to write about human beings; that to prefer, as Lewis claims he does, the 'outsides' of people to their 'insides', to be in favour of, as he called it, The Great Without rather than The Great Within, is to disqualify oneself as a good portrayer of human relationships. F. R. Leavis points with dismay to what he terms Lewis's 'hardboiled' attitudes towards sex, and contrasts him unfavourably with D. H. Lawrence. Let us consider this by looking at one last passage from Snooty Baronet, this one describing an after-dinner movement towards bed involving Snooty and his mistress Val:

8

Replacing my glass upon the table empty, I leered at her again, and this time she leered back. She dropped the School Miss overboard, and ran up with a will the Jolly Roger.

'Come Valley!' I muttered cordially.

She grappled with me at once, before the words were well out of my mouth, with the self-conscious gusto of a Chatterly-taught expert. But as I spoke I went to meet her—as I started my mechanical leg giving out an ominous creak (I had omitted to oil it, like watches and clocks these things require lubrication). I seized her stiffly round

the body. All of her still passably lissom person—on the slight side—gave. It was the human willow, more or less. It fled into the hard argument of my muscular pressures. Her waist broke off and vanished into me as I took her over in waspish segments, an upper and nether. The bosoms and head settled like a trio of hefty birds upon the upper slopes of my militant trunk: a headless nautilus on the other hand settled upon my middle, and attacked my hams with its horrid tentacles—I could feel the monster of the slimy submarine-bottoms grinding away beneath, headless and ravenous.

'Oh Listerine!' I sighed, as I compressed the bellows of her rib-box, squeezing it in and out—it crushed up to a quite handy compass—expanding, and then expelling her bad breath. I put my face down beside her ear (I wished I'd brought her a bottle from the States as a useful present).

I was well away, I left much behind me I give you my word in those first spasms of peach-fed contact. Squatted upon the extremity of the supper-table, with my live leg (still laden with hearty muscles) I attacked the nether half of my aggressive adversary, and wound it cleverly around her reintegrating fork. (We were now both suspended upon my mechanical limb.)

Snooty Baronet, 2 'Val'

How 'hardboiled' is this attitude and indeed what exactly is the 'attitude' towards sex present here? It would probably be agreed that we do not receive any sympathetic entry into Val's inner thoughts and feelings, while Snooty's are rather minimally, if strikingly, conceived by his sighing. 'Oh Listerine!' We see the pair grapple, then break off into various segments and settlings and seizures; compressings of rib-boxes occur, as do muscular pressures and the grinding of tentacles. Is it then a presentation of sex in the modern world where people are reduced to mechanical parts and a meaningless grinding of gears?

Such might be the case if Lewis had chosen to be a moralist, to shake his head over the depressing spectacle of Snooty and Val. But about the time this book was written (1932), and indeed from the very beginning of his career, Lewis spent a great amount of energetic words trying to convince us and himself that 'The Greatest Satire is Non-Moral'. One of the things meant by this slogan was that the kind of satire he wanted to write would not attack vice, but would set forth things (like sex) as they are. But as we can see from the Snooty passage, there is nothing neutral or 'objective' about the presentation. Val grapples with Snooty 'with the self-conscious gusto of a Chatterly-taught expert' and we know that Val has been reading books and picking up tips. But throughout the passage Lewis uses words with an analogously self-conscious gusto; sentences crackle and snap as if every moment counted. Crazy crises occur: one's mechanical leg gives out a creak because, alas, one has forgotten to oil it; one's mistress for all her Chatterley-expertise could do with a bit of Listerine; both end up suspended upon the un-oiled mechanical limb—a neat trick. Lewis seems to be having a lot of fun in this passage, as if to say, let's see if we can describe a sexual encounter as no more than 'hard arguments of muscular pressures'. Surely, reader, you are tired of having an author tell you how deeply she felt about him, or how strongly his heart beat in response to her? In so far as the passage represents an enlivening and refreshing of language put to satiric or comic uses we feel exhilarated rather than depressed. Perhaps anything this genially creative cannot be very hardboiled after all.

As for Lawrence's supposedly less-hardboiled, more sympathetically human treatment of sexual relationships, consider this culminating passage from the 'Excurse' chapter

in *Women in Love* where Ursula and Birkin consummate their love:

They threw off their clothes, and he gathered her to him, and found her, found the pure lambent reality of her forever invisible flesh. Quenched, inhuman, his fingers upon her unrevealed nudity were the fingers of silence upon silence, the body of mysterious night upon the body of mysterious night, the night masculine and feminine, never to be seen with the eye, or known with the mind, only known as a palpable revelation of mystic otherness.

She had her desire of him, she touched, she received the maximum of unspeakable communication in touch, dark, subtle, positively silent, a magnificent gift and give again, a perfect acceptance and yielding, a mystery, the reality of that which can never be known, mystic, sensual reality that can never be transmuted into mind content, but remains outside, living body of darkness and silence and subtlety, the mystic body of reality. She had her desire unfilled. He had his desire fulfilled. For she was to him what he was to her, the immemorial magnificence of mystic, palpable, real otherness.

Evidently it was pretty good, but it is not immediately clear why we should necessarily feel better about human sexual possibility when we read Lawrence than in hearing about Snooty's grapple with Val. Lawrence prefers metaphors that attempt to express the inexpressible. What are you to me, dear? You are the 'immemorial magnificence of mystic, palpable, real otherness'. But of course this way of writing is at least as strange as moving around mechanical segments of the lovers' bodies in the way Lewis's words do. It is perhaps a matter of one's temperament and taste: I myself find that I am invigorated and feel better generally about life after exposure to the self-conscious mechanical gusto of Lewis's prose.

Criticism as performance: literary

When F. R. Leavis apostrophized the 'brutal and boring Wyndham Lewis' in his Richmond Lecture of 1963, he descended to alliterative name-calling rather than criticism. But many people assume that some word like 'brutal' is an accurate description of Lewis's reputedly abrasive commentaries on his contemporaries, his enemies, even his onetime or continuing friends. Probably no other contemporary writer has left as many passages of sharp characterization and criticism of his peers: those whom he admired, but never to the point of suspending his criticism of them —Pound, Eliot, Joyce; those whom he disliked or had contempt for—Gertrude Stein, D. H. Lawrence, Virginia Woolf; those who commanded mixed portions of admiration and scorn—Hemingway, George Orwell, Sartre. Anyone interested in Lewis's career will of course be anxious to work out the particular ups-and-downs in his attitudes towards certain of these writers; to trace, for example, the complicated shape of his relationship with Pound. Our purposes here are different and involve an examination of how Lewis goes about presenting or creating the character, writer or book he is criticizing. What distinguishes Lewis's hostile critiques of his contemporaries from those of most other critics I know is that they are invariably very funny; also that they appeal to us and remain in our

minds afterwards out of all proportion to any pretence they make to being 'objectively' true. And as we read them we are far from operating as rational beings, calmly and dispassionately judging whether or not a particular remark or metaphor is or is not just: caught up by the flare and excitement of Lewis's rhetoric we spend our energies in trying to keep up with his performance, to 'participate' in the show he so vigorously sets before us.

Let us begin with a passage in which a famous literary character (though not so famous in 1927 when Lewis wrote this) is distinguished from his companions in the opening chapter of Joyce's *Ulysses*:

9

But if they are clichés, Stephan Dedalus is a worse or a far more glaring one. He is the really wooden figure. He is 'the poet' to an uncomfortable, a dismal, a ridiculous, even a pulverizing degree. His movements in the Martello-tower, his theatrical 'bitterness', his cheerless, priggish stateliness, his gazings into the blue distance, his Irish Accent, his exquisite sensitiveness, his 'pride' that is so crude as to be almost indecent, the incredible slowness with which he gets about from place to place, up the stairs, down the stairs, like a funereal stage-king; the time required for him to move his neck, how he raises his hand, passes it over his aching eyes, or his damp brow, even more wearily drops it, closes his dismal little shutters against his rollicking Irish-type of a friend (in his capacity of a type-poet), and remains sententiously secluded, shut up in his own personal Martello-tower—a Martello-tower within a Martello-tower—until he consents to issue out, tempted by the opportunity of making a 'bitter'—a very 'bitter'— jest, to show up against the ideally idiotic background provided by Haines; all this has to be read to be

believed—but read, of course, with a deaf ear to the really charming workmanship with which it is presented. *Written* on a level with its conception, and it would be as dull stuff as you could easily find.

Time and Western Man, Book 1, ch. 16

Lewis assumes Joyce is fully approving of Stephen Dedalus, incapable of any satiric glance towards his poet-hero. This is probably not true, though it makes no difference to the effectiveness with which Stephen is brought before our eyes. Certain phrases like 'cheerless, priggish stateliness' are excellent readings of the character as we construct it from the open chapter of *Ulysses*, but Lewis is not content to leave it at accurate description. Joyce never tells us that Stephen's brow is damp, nor that his eyes are aching; these theatrical details are added by Lewis to make an even more wooden figure (or puppet) than is there in Joyce's book. Some might argue that such criticism is irresponsible, that it disfigures rather than illuminates the book under consideration, and that to speak of Stephen's eyes as 'dismal little shutters' is to substitute a novel of your own for the one Joyce wrote. A more interesting alternative could be to accept these comic exaggerations as deliberately 'unfair' ways of putting a strong case for the necessity of detaching ourselves as readers from this 'hero'. Probably because Lewis put the case against Stephen as forcefully as he did, later critics have found he was worth arguing with.

Here is a description of the method of *Ulysses* as a whole:

At the end of a long reading of *Ulysses* you feel that it is the very nightmare of the naturalistic method that you have been experiencing. Much as you may cherish the merely physical enthusiasm that expresses itself in this stupendous outpouring of *matter*, or *stuff*, you wish, on the spot, to be transported to some more abstract region for a time, where the dates of the various toothpastes, the brewery and laundry receipts, the growing pile of punched 'bus-tickets, the growing holes in the baby's socks and the darn that repairs them, assume less importance. It is your impulse perhaps quickly to get your mind where there is nothing but air and rock, however inhospitable and featureless, and a little timeless, too. You will have had a glut, for the moment (if you have really persevered) of *matter*, procured you by the turning on of all this river of what now is rubbish, but which was not *then*, by the obsessional application of the naturalistic method associated with the exacerbated time-sense. And the fact that you were not in the open air, but closed up inside somebody else's head, will not make things any better. It will have been your catharsis of the objective accumulations that obstinately collect in even the most active mind.

Now in the graphic and plastic arts that stage of fanatic naturalism long ago has been passed. All the machinery appropriate to its production has long since been discarded, luckily for the pure creative impulse of the artist. The nineteenth century naturalism of that obsessional, fanatical order is what you find on the one hand in *Ulysses*. On the other, you have a great variety of recent influences enabling Mr. Joyce to use it in the way he did.

The effect of this rather fortunate confusion was highly stimulating to Joyce, who really got the maximum out of it, with an appetite that certainly will never be matched again for the actual *matter* revealed in his composition, or proved to have been lengthily secreted there. It is like a

gigantic victorian quilt or antimacassar. Or it is the volu-
minous curtain that fell, belated (with the alarming
momentum of a ton or two of personally organized rub-
bish), upon the victorian scene. So rich was its delivery,
its pent-up outpouring so vehement, that it will remain,
eternally cathartic, a monument like a record diarrhoea.
No one who looks *at* it will ever want to look *behind* it.
It is the sardonic catafalque of the victorian world.

Time and Western Man, Book 1, ch. 16

As criticism of *Ulysses* I do not think this has ever been
bettered. But whether or not you agree with the emphasis
on Joyce as supreme applicant of the naturalistic method,
you will find it hard to forget Lewis's literal working-out
of the usually inert catharsis metaphor; there is a fine
double-edge on the characterization of this 'delivery' as
'rich' when we realize that it may be rich like a record
diarrhoea. In this performance Lewis strives for succes-
sively more outrageous ways and extremes to handle
Joyce's monumental book. He is concerned to make the
very interesting argument that what it looks and feels like
is much more important and inescapable than anything it
may *mean* ('no one who looks *at* it will ever want to look
behind it') but he makes that argument by overwhelming
us with extravagant metaphors to the extent that is hard
to take issue with him. How do you take issue with
prose which describes another book as 'a monument
like a record diarrhoea' or 'the sardonic catafalque of the
victorian world'?

One of Lewis's masters in the field of creative-destructive
criticism of another writer (or, in the case of the follow-
ing paragraph, artistic movement) was Ruskin, whose
stylistic temperament was as intense though usually more
severe than Lewis's. In the introduction to *The Demon of
Progress in the Arts* Lewis quotes with approval of its mag-

29

nificence the following sentences in *The Stones of Venice* denouncing post-Renaissance painting:

Instant degradation followed in every direction—a flood of folly and hypocrisy. Mythologies, ill-understood at first, then perverted into feeble sensualities, take the place of the representation of Christian subjects, which had become blasphemous under the treatment of men like the Caracci. Gods without power, satyrs without rusticity, nymphs without innocence, men without humanity, gather into idiot groups upon the polluted canvas, and scenic affectations encumber the streets with preposterous marble. Lower and lower declines the level of abused intellect; the base school of landscape gradually usurps the place of the historical painting, which had sunk into prurient pedantry, —the Alsatian sublimities of Salvator, the confectionery idealities of Claude, the dull manufacture of Gaspar and Canaletto, south of the Alps, and in the north the patient devotion of besotted lives to delineation of bricks and fogs, cattle and ditchwater.

One can applaud the magnificence of this passage, culminating in that extraordinary final delineation, and still look at Claude with pleasure or admire some of the cattle and ditchwater those besotted lives produced. Ruskin's criticism is exhilarating for the way it reveals a strong uncompromising single-minded pleading of a case; and this is exactly the sort of merit found in Lewis's criticism at its most powerful. Like Ruskin, he does not tend to see both sides of an issue, does not find himself uncertain as to where to put his emphasis.

In 1927 Lewis produced the first issue—it was to run for two more—of a one-man periodical called *The Enemy* for which he designed the covers and wrote most of what went between them. This periodical gave him a chance to

criticize whatever currently fashionable tendency in art or politics he thought needed attention; and he was also on the lookout for any best-selling work of literature or non-literature that could be analysed for its sociological revelations. An example of the latter sort of book fell his way when Kathryn Mayo published *Mother India*, which presumed to give the low-down on sexual customs in India, but which relied heavily on nineteenth-century statistics and was written in a rather superior tone. Lewis's way of dealing with the book, after preliminary criticisms, is to imagine the following vignette where the roles are reversed and a clever Indian lady journalist decides to write a *Mother America* and see what can be dug up about sexual habits in the USA. Here is the possible result:

II

The indian lady visitor to the United States, let us suppose, has arrived. She 'courteously' requests to be 'shown over', and in her book she can say how very 'courteous' at least (that looks well, it shows how fair and unbiassed you are), everybody was (how very *stupidly* courteous to such a person she may privately reflect); and she could (very easily) have a remarkably 'highly-placed diplomatist' or 'a great inventor' perhaps (that would look well) always at her elbow, just as Miss Mayo always has a *particularly* 'high-caste Brahmin' at her elbow, to inform against *other* high-caste Brahmins: the indian lady visitor or inquisitor, the 'restless analyst' from the East, could quote extensively from some american equivalent of the *Loom of Youth*, and tell the horrified Indian Public how in all the schools and universities of the United States homosexuality was rampant: then she would tell the usual stories of pregnant high-school girls—reveal whole classes carried away in one brake to the Lying-in Hospital: she could state *as a fact*

that all american men were sexually impotent at thirty (hence the Broadway girl-shows), and that self-abuse was intense and universal throughout the 48 states of the Union: she could describe the death-rate per day in an american city by violent crime, quote Mencken for bits about the monstrosities of Prohibition: and she could wind up by saying that America is 'a physical menace' (cf. p. 23, *Mother India*) to the Hindu...

And then, of course, she could quote Prescott's *Conquest of Mexico* to give an idea of the sort of blood-sacrifices currently perpetuated by the Americans. This she could easily mix up with the Ku Klux Klan, and say that they disembowelled fifty Negroes a day in any fair-sized american city.

This book she would call (in Tamil) *Hail Columbia, Happy Land.*

This is a sort of book, at all events, that you can't have enough of, both ways, and all ways. It promotes that excellent feeling of brotherly love between nations and races that is so very useful and comfortable for all of us.

Paleface, Appendix

An example of Lewis at his broadest, most relaxed and outrageous. The relish with which he develops this fantasy of *Mother America* is surely evident; when he says sarcastically that Kathryn Mayo has written the kind of book 'you can't have enough of' there is also a sense in which he speaks true. For the satirist (cf. Flaubert or Joyce) lives and feeds on the sustenance provided him by pieces of vulgarity like *Mother India*. Or to change the metaphor, such a book provides Lewis with a springboard from which he can launch into piece after piece of high-spirited distortion and exaggeration. Just how rampant homosexuality and whole classes of high-school girls being carried away to the lying-in hospitals go together (in America) or what exactly they have to do with Miss

Mayo's book, is not a very bothersome question once you've given yourself to Lewis's performance and are mainly eager to see what he can come up with next. And in that sentence about *Hail Columbia, Happy Land* (in Tamil) he manages to top off and conclude the whole act. To some extent any satirist or critic must have his energies engaged by that which he is attacking: consider in the case of Ruskin, the enthusiasm with which time and again he abused Salvator and Claude in *Modern Painters*. But Lewis becomes obsessively fascinated by the character or situation he is attacking and cannot cease dwelling upon their so palpable absurdities. So that after reviewing Edith Sitwell's *Aspects of Modern Poetry* (the review was called 'Sitwell Circus') he responded in the following way to a letter from brother Osbert that mentioned Lewis slurringly:

12

That Osbert and myself should wag our greybeard-noodles at each other in public defiance is setting a bad example, undoubtedly, to the youthies—to the plump little budding Osberts and just-weaned winsome Wyndhams: but expostulate I must to this extent—Have I not alone, of all critics, refrained from insisting upon misquotations and all that? Did I not quite pass that over in my review of Edith's *Aspects*? And *this* is what I get in return? I cannot suppress a reproachful wag or two!—*Ingrat*! no wonder I exclaim!—Yes, I confined myself—when I came to write of this rococo palace of blunder, this wax-works divided into 'giants' before whom you abase yourself, and sots or desperados at whose effigies you spit and jeer—to the rather amusing *Circus* aspects of the performance. I tried to bring out the truly disarming picture of these incorrigibly 'naughty', delicately shell-shocked, wistfully age-com-

plexed, wartime Peter Pans—dragging out of their old kit-bags for the thousandth time their toy 'great men' (about whom they go girlishly lyrical, and cover with a cheap varnish of unreality); their Aunt Sallies; their aviary of love-birds, toucans and tomtits; their droned-out nursery-melodies, accompanying the plunges of the old rocking-horses. A bit sad, a thought dreary, like all circuses that have survived—dominated, this one, by the rusty shriek of the proprietress: all *that* I did my best to bring out and to make people forget the constant and alas! symptomatic lapses of memory occurring in the patter, the placards upside down—letters missing from the gilt blazoning of the announcement, making nonsense as often as not. For this trio *does* 'belong to the history of publicity rather than that of poetry' (cf. Dr. Leavis): and would you expect Milton to be correctly quoted in an advertisement for Massage or Male-corsets—or Gerard Manley Hopkins to appear without printer's errors in a blurb recommending the tired pirouettes of a Society authoress? It would be unreasonable. It would be asking far too much of everybody concerned.

<div align="center">Yrs etc.</div>

<div align="right">WYNDHAM LEWIS</div>

Hyde Park

<div align="right">*The Letters of Wyndham Lewis*, p. 229</div>

The Hyde Park address was a joke, made to counter Osbert's Chelsea address. (Lewis, in fact, lived in humble Notting Hill.) In developing the circus metaphor as expressive of the Sitwells' endeavour, Lewis himself performs in a circus-manager-like way, making sure that everything which can possibly do up the Sitwells one more way, or give the reader one more laugh of approval, will be brought on stage, right down to that final fake address. In fact the whole thing does not sound very mean-spirited, partly because Lewis so loudly plays the decent wounded fellow

who had not mentioned Edith's misquotings (had he noticed them?) and now 'cannot suppress a reproachful wag or two!— *Ingrat*!' There is, in other words, an attractive art in this abuse: we do not end up thinking what an awful person Edith or Osbert Sitwell was because we are responding to a creation of words that, for all its origins in animus or malice, takes on a reality independent of persons and issues.

This is what T. S. Eliot was describing when he said in relation to Dryden's satire that it 'creates the object it contemplates' so that ridiculous people like Shadwell in 'MacFlecknoe' become, under the touch of Dryden's language, gloriously or marvellously ridiculous, standing 'confirmed in full stupidity'. We are often admonished these days not to criticize something unless that criticism is made in a 'constructive' sense. Supposedly there is something called purely destructive criticism which is not useful or not fair, or just not done. But as it would be hard to say whether Ruskin's criticism of the 'flood of folly and hypocrisy' which followed on Renaissance painting was 'destructive' or 'creative' in putting vividly before us the art Ruskin despised, so Lewis makes sure Edith Sitwell or the author of *Mother India* will likewise not pass into oblivion. Creative and destructive impulses are intimately tied together when the satirist operates at full strength.

The creative-destructive mixture becomes most interestingly apparent when Lewis is genuinely of two minds about the book or writer he is criticizing. The following excerpts are from the chapters on Ernest Hemingway and William Faulkner in *Men Without Art*. Both of them were written in the early 1930s before either Faulkner and Hemingway were fully established values; thus the critiques, as with the early ones of Pound and Joyce, show Lewis's willingness to take risks, go out on a limb, over-

state a partial but extremely acute view of his subject. Think of how dull most books on Hemingway still are in 1971, then consider these two paragraphs in which Lewis invokes the 'First-person-singular' hero of a Hemingway novel or story:

13

The sort of First-person-singular that Hemingway invariably invokes is a dull-witted, bovine, monosyllabic simpleton. This lethargic and stuttering dummy he conducts or pushes from behind, through all the scenes that interest him. This burlesque First-person-singular behaves in them like a moronesque version of his brilliant author. He *Steins* up and down the world, with the big lustreless ruminatory orbs of a Picasso doll-woman (of the semi-classic type Picasso patented, with enormous hands and feet). It is, in short, the very dummy that is required for the literary mannerisms of Miss Stein! It is the incarnation of the Stein-stutter—the male incarnation, it is understood.

But this constipated, baffled, 'frustrated'—yes, deeply and Freudianly 'frustrated'—this wooden-headed, leaden-witted, heavy-footed, loutish and oafish marionette—peering dully out into the surrounding universe like a great big bloated five-year-old—pointing at this and pointing at that —uttering simply 'CAT!'—'HAT!'—'FOOD!'—'SWEETIE!' —is, as a companion, infectious. His author has perhaps not been quite immune. Seen for ever through his nursery spectacles, the values of life accommodate themselves, even in the mind of his author, to the limitations and peculiar requirements of this highly idiosyncratic puppet.

So the political aspects of Hemingway's work (if, as I started by saying, one can employ such a word as *political* in connection with a thing that is so divorced from reality as a super-innocent, queerly-sensitive, village-idiot of a few words and fewer ideas) have to be sought, if anywhere,

in the personality of this *First-person-singular*, imposed upon him largely by the Stein-manner.

Men Without Art, ch. 1, 'The Dumb Ox'

It is now common to speak about how deep the still waters run in a Hemingway first-person narrator like Frederick Henry; but Lewis's portrait of the puppet who cannot say much points instead to the puppet's significant charm and limitation. A narrative by such a companion is indeed 'infectious'; it also has political implications, though Lewis does not go on at this point to develop them. But notice that he is insistent on moving from style to politics by suggesting that the kind of viewpoint you choose to tell your story from will both shape the story and imply something about your attitudes towards society, towards the world. The further suggestion is that Hemingway both is and is not detached from his first-person-creation, therefore is not simply a satirist (detached) or a lyricist (identified with) but some very interesting mixture of the two. And this is in fact how Hemingway works when he works most complexly.

It might be amusing to inspect the opening of a novel (actually the second and third paragraphs) Lewis wrote at about the same time as he composed the criticism of Hemingway:

14

The face was on-the-lookout behind the window-glass of the taxicab. The left eye kept a sullen watch: it was counting. Numbers clicked-up in its counting-box, back of the retina, in a vigesimal check-off. When it had counted up to a thousand and forty—starting however at four hundred and eighty (a *fifteen-cent* yellow knickerbocker,

as luck would have it) the taxi stopped. The face drew back. The door opened. Grasping the forward jamb, a large man thrust out one leg, which was straight and stiff. Pointing the rigid leg downwards, implacably on to the sidewalk, the big man swung outward, until the leg hit terra-firma. The whole bag-of-tricks thus stood a second crouched in the door of the vehicle. Then stealthily there issued from its door, erect and with a certain brag in his carriage, a black-suited six-footer, a dollar-bill between his teeth, drawing off large driving gauntlets.

The face was mine. I must apologize for arriving as it were incognito upon the scene. No murder has been committed at No. 1040 Livingston Avenue—I can't help it if this has opened as if it were a gunman best-seller.—The fact is I am a writer: and the writer has so much the habit of the anonymous, that he is apt to experience the same compunction about opening a book in the First Person Singular (caps for the First Person Singular) as an educated man must feel about commencing a letter with an 'I'. But my very infirmity suggested such a method. I could hardly say: 'The taxi stopped. I crawled out. I have a wooden leg.' Tactically, that would be hopelessly bad. You would simply say to yourself, 'This must be a dull book. The hero has a wooden leg. Is the War not over yet?' and throw the thing down in a very bad temper, cursing your Lending Library.

Snooty Baronet, I 'New York'

The joke here lies in the narrative switch between paragraphs, from traditional third person narrative (of the sort that a 'gunman best-seller' might employ) to mock-embarrassed first-person apologetic ('I can't help it...' etc.). It would be true to say that, as in the essay on Hemingway's style, Lewis is making a point about the difference it makes that you tell your story—whatever it is—one way rather than another; but that 'point' is made only

through a very broad and loud joke. This fictional situation in which an author builds into his novel certain jokes about and criticisms of the whole business of writing fiction is very much in vogue at present, witness (to name only two) the work of Nabokov and John Barth. As usual Lewis was a number of years ahead of the game; and *Snooty Baronet* may be enjoyed for the kinds of awareness and parody of the novel form it reveals.

The criticism of Faulkner goes directly to that writer's use of words:

15

But there is a lot of poetry in Faulkner. It is not at all good. And it has an in the end rather comic way of occurring at a point where, apparently, he considers that the *atmosphere* has run out, or is getting thin, by the passage of time become exhausted and requiring renewal, like the water in a zoological garden-tank for specimens of fish. So he pumps in this necessary medium, for anything from half a dozen to two dozen lines, according to the needs of the case. This sort of thing:

> 'Moonlight seeped into the room impalpably, refracted and sourceless; the night was without sound. Beyond the window a cornice rose in a succession of shallow steps against the opaline and dimensionless sky.'

His characters demand, in order to endure for more than ten pages, apparently, an opaque atmosphere of whip-poor-wills, cicadas, lilac, 'seeping' moonlight, water-oaks and jasmine—and of course the 'dimensionless' sky, from which the moonlight 'seeps'. The wherewithal to supply them with this indispensable medium is as it were stored in a *whip-poor-will tank*, as it might be called: and he pumps the stuff into his book in generous flushes at the

slightest sign of fatigue or deflationary listlessness, as he thinks, upon the part of one of his characters.

To compare him with Ernest Hemingway as an artist would indeed be absurd: but actually he betrays such a deep unconsciousness in that respect as to be a little surprising. In the above passage (about the *impalpable seeping of the moonlight*) you may have remarked a peculiar word, 'sourceless'. If in reading a book of his you came across this word ... and said to yourself '*Sourceless*'— what for mercy's sake is that!' you would soon find out. For a dozen pages farther on (where more poetic atmosphere was being pumped in, in due course) you would probably come across it again: and after you had encountered it half a dozen times or so you would see what he meant.

Men Without Art, ch. 2

Lewis proceeds to give examples of Faulkner's use of 'sourceless', 'myriad', and of other words, but the particularly acute remark occurs when he considers the matter of how a reader knows what a word means in a Faulkner novel. Rather than looking it up in the dictionary (where it may not be) the suggestion is that you read on, that inevitably you will meet with it again, and that you will recognize it as a guarantee of 'atmosphere' or 'poetry' and therefore learn to accept it and understand it, though you may not admire it as a splendid use of language. Thus he suggests that Faulkner's interest as a novelist, like Dostoevsky's, is somehow beyond or independent of his capacities as a stylist—as Hemingway's is not. Lewis does not make the mistake of thinking he has disposed of Faulkner's appeal by identifying and invoking the whip-poor-will tank of poetic excess, and he goes on, with reference to *Sanctuary*, to describe the power of what he calls this 'Moralist with a Corn-Cob'.

It cannot be overstressed that what makes Lewis's criticism of other writers and other books so useful is that he writes from the reader's standpoint, that is, he begins with his own common-sense responses to a page in some novel and trusts that response, rather than consulting the authorities in advance to find out what he's supposed to be feeling. All of us in reading Faulkner have experienced a moment when we have come across a word like 'sourceless' and said to ourselves or out loud the equivalent of 'What for mercy's sake is that!' We have also learned in part at least how not to be too bothered by Faulkner's idiosyncratic excesses, indeed we may even have become fond of them. But Lewis knows that really to appreciate the virtues of an author you must be willing to mount your best criticism on what seems to you his weak point, his excesses, his ludicrous moments. If then you can still go on and read him with pleasure you have found out something about his staying power.

The final excerpt in this section is a rather long one in which Lewis proposes what he calls 'The Taxi-Cab Driver's Test for "Fiction" '. The context for this proposal was his annoyance at the lumping together of all imaginative works of literature as 'fiction' and the assigning of them to 'fiction' reviewers who then regularly discovered masterpieces but were incapable, he felt, of doing justice to the 'fiction' Lewis himself wrote in the late 1920s—*The Childermass* or *The Apes of God*. Instead, however, of straightforwardly and directly making a plea for different standards he launches the following performance:

16

The term 'fiction' as used to describe all prose narrative, would be unobjectionable, if 'fiction' had not a significance

of a special order at the present time. But what it is used to describe upon the contemporary Scene makes it inadmissible where any serious work of literary art is concerned. No work of fiction is, I believe, in the fullest sense, also a work of art, which could not pass the following simple test. I believe that you should be able to request a taxi-cab driver to step into your house, and (just as you might ask him to cut a pack of cards) invite him to open a given work of fiction, which you had placed in readiness for this experiment upon your table; and that then *at whichever page he happened to open it*, it should be, in its texture, something more than, and something different from, the usual thing that such an operation would reveal. In fact, allowing for the difference of scale and of technical approach, a work of 'fiction' should be as amenable to this test as would be a play by Molière or Racine, of any page taken at random in, say, the Collected Works of Donne or of Dryden. The 'fiction' selected need not, of course, possess the genius of those great writers, but it should be, as it were, *an intellectual object* of a similar order to their works.

Yet upon any terms, that would be a critical scrutiny that few people would admit as decisive, in the case of their favourite 'fiction'. No, for them 'fiction' is *in places*, 'literature'; in other places (and in most places) it is just slovenly blah, that (since it amuses—since it is a sort of folk-prose of the Middle-Classes of Western Democracy) must be tenderly handled by the critic. No implements of precision may be used against it; in some mysterious, some most ill-defined, manner, it is *the whole* that counts. Any given page of it may, as a specimen of the literary art, be beneath contempt. Far from being an *intellectual object*, it need not be an object at all, or at the most it need only be an object that recalls a sprawling jelly of the vulgarest sentiment.

And there you have, no doubt, the sufficient reason for the phenomenon we must all have noticed, namely, that a

hundred books of 'fiction' every month are referred to by eminent critics in language of such superlative praise that, were it the work of Dante that was in question, it would be adequate, though a little fulsome: but, when used to describe the legion of lady-novelists and gentlemen fictionists too, it must seem either bereft of reason, or else peculiarly dishonest and mercenary...

I would go so far upon that purist road myself as to say that *no* book that could be possibly made to fit into the scheme of things suggested by the word 'fiction' could possibly be a work of the least importance. No book that would not pass my taxi-cab-driver test, that is, would be anything but highly suspect as art—though it might be an awfully good aphrodisiac, or a first-rate 'thriller'.

But I will at once proceed to a demonstration of how my fiction-test would work.

The *taxi-cab-driver test* can be applied, in the absence of a taxi-cab-driver—though not so effectively—by merely opening any book of 'fiction', at the first page, and seeing what you find.

Men Without Art, Appendix

Lewis then proceeds to open 'two of the only "fiction" books I have within easy reach' and quotes paragraphs from the first page of each. Exhibit A turns out to be the beginning of Huxley's *Point Counterpoint*, and Lewis deftly and closely analyses what he calls the 'tone of vulgar complicity with the dreariest kind of suburban library-readers', then argues that whatever happens in the rest of that 600-page book it cannot become anything but a 'dull and vulgar book'. His second example is the opening few sentences from Henry James's *The Ivory Tower* which he contents himself with terming 'rather a different kettle of fish, the most unobservant must detect'. As it most certainly is. But both these works the literary world classifies as 'fiction', and it is then presumed they have

something important in common. Lewis's attempt was to break down the rigidity and solemnity of our categories for understanding things when those categories actually impede and frustrate understanding. Any teacher who has practised with students the taxi-cab-driver's test on the first page of some piece of 'fiction' will perhaps agree that it is a liberating way to approach a novel, even though we know one page does not tell us everything about the book. It does tell us a great deal about the kind of mind behind the book and the choices that mind makes about how to begin its story, what kind of relationship and tone to establish with the reader. And it is brilliantly memorable because of that taxi-driver who never shows up to perform the test, but is so splendidly there in the fantasy Lewis weaves around him.

Criticism as performance: sociological and cultural

One of the reasons for reading Wyndham Lewis, in addition to the continual encountering of interesting verbal performances, is that scattered throughout his books in one form or another can be found prophecies of the world we find ourselves now living in. Reading Saul Bellow's recent novel, *Mr. Sammler's Planet*, one is struck by the conscious or unconscious echo, in the soliloquies of Sammler or other characters, of pages from Lewis's books about this or that aspect of modern life. Compared with H. G. Wells or Galsworthy, or indeed with E. M. Forster, Ford Madox Ford and even Lawrence, Lewis's critiques smack remarkably little of 'period' interest; they seem to me to have dated almost not at all and can be read today as reflections on the life of society by a strong, opinionated, brilliant, sometimes reckless but always provocative analyst. The selections in this chapter will try to give some sense of the breadth and range of Lewis's non-literary criticism, much of which appeared during the late 1920s and early 1930s but was never absent from his work after that point. Nor indeed before that point, as we can see from this passage from the unrevised (1918) version of *Tarr* in which Tarr, clearly speaking some ideas provided to him by his creator, delivers a sermon on English Humour:

17

With the training you get in England, how can you be expected to realize anything? The University of Humour that prevails everywhere in England as the national institution for developing youth, provides you with nothing but a first-rate means of evading reality. The whole of English training—the great fundamental spirit of the country—is a system of *deadening feeling*, a prescription for Stoicism. Many of the results are excellent. It saves us from gush in many cases; it is an excellent armour in times of crisis or misfortune. The English soldier gets his special *cachet* from it. But for the sake of this wonderful panacea —English humour—we sacrifice much. It would be better to *face* our Imagination and our nerves without this soporific. Once this armature breaks down, the man underneath is found in many cases to have become softened by it. He is subject to shock, over-sensitiveness, and many ailments not met with in the more frank and direct races. Their superficial sensitiveness allows of a harder core.—To set against this, of course, you have the immense reserves of delicacy, touchiness, sympathy, that this envelope of cynicism has accumulated. It has served English art marvellously. But it is probably more useful for art than for practical affairs. And the artist could always look after himself. Anyhow, the time seems to have arrived in my life, as I consider it has arrived in the life of the country, to discard this husk and armour. Life must be met on other terms than those of fun and sport.

Tarr, part 2, ch. 2

Granted that Tarr at this moment is trying out his ideas, seeing exactly where they will bring him out, and that we are reading a novel, not simply being let in on what Lewis believed. But this is the sort of passage that remains interesting at a second reading and beyond. How does it oper-

ate? By beginning with scorn towards 'The University of Humour' (Lewis was not at Oxford or Cambridge) that one might read about in *Zuleika Dobson* or encounter embodied in a clever young man from one of D. H. Lawrence's short stories. Lewis-Tarr is not unattracted by the virtues of deadening feeling in this way; he is impressed by the 'excellent armour' it provides the soldier, or any of us in times of misfortune. But perhaps the man inside the armour will turn to jelly, perhaps, like Forster's unexpressive Mr Wilcox, there will be no true voice of feeling, no connection between inside and outside. Again, on the other side, a humorous attitude of life may be productive of impressive delicacy or sympathy or touchiness, maybe even useful for the artist. But again, no; perhaps Tarr like Lewis has been reading his Dostoevsky and will insist that we face life with something other than what he refers to in the Epilogue as a 'self-defensive grin'. We must begin to be proud of our feelings.

Remember that *Tarr* was written not too far from the time of *Howards End* or *The Forsyte Saga*; and that that opening sentence—'With the training you get in England, how can you be expected to realize anything'—might have been somebody's effective riposte in a play by Shaw or Oscar Wilde, or a line in Samuel Butler's *Notebooks*. But we can feel Tarr and Lewis's desire to take on the world here, or at least England, in some kind of combat. A serious young man finding his countrymen insulated, complacent, and good chaps, all must break out of this cosy bag; he does this by lining them up, categorizing them and, for himself, facing in another direction. In this relatively genial and even tolerant passage, the person later known as 'The Enemy' is embryonic.

Tarr is an artist though, no ordinary man, and it should not be assumed that either in this novel, or in the books of

sociological analysis Lewis went on to write in the 1920s and 1930s, the writer is calling for a revolutionary casting-off of chains. As *The Art of Being Ruled* put it time and again, using Goethe's distinction, most men are puppets rather than 'natures'—as Tarr, the artist, is a nature. Since there is something contradictory about the very idea of a puppet 'expressing' "his" 'personality' Lewis set out to point up what actually goes on in the world with the intent, he claimed, of helping people to understand the science or art of being ruled. It is not quite clear how if most men are puppets they will be able to read the book, cultivate the virtues of detachment and passivity—of Stoic apathy—and thus make their lots easier in what Lewis calls 'the power-house' of the modern state; it is however quite clear that Lewis's dislike of political men of action was also a fascination with them, and that (as he suggested later) the Utopia which emerged from *The Art of Being Ruled* was one of 'quiescence, obedience, receptivity'. Exactly what this had to do with certain totalitarian regimes in non-Utopian Europe is of course another story. Lewis's ambivalence towards Mussolini in 1925 can be seen in this book; the more disastrous infatuation with Hitler came later. Here is a passage taken from a discussion of how modern man, a puppet in a powerhouse state, expresses his personality:

18

Generally speaking, it can be said that people wish to escape from themselves (this by no means excluding the crudest selfishness). When people are encouraged, as happens in a democratic society, to believe that they wish 'to express their personality', the question at once arises as to what their personality *is*. For the most part, if investigated, it would be rapidly found that they had none. So what would

it be that they would eventually 'express'? And why have they been asked to 'express' it?

If they were subsequently watched in the act of 'expressing' their 'personality', it would be found that it was somebody else's personality they were expressing. If a hundred of them were observed 'expressing their personality', all together and at the same time, it would be found that they all 'expressed' this inalienable, mysterious, 'personality' in the same way. In short, it would be patent at once that they had only *one* personality between them to 'express'—some 'expressing' it with a little more virtuosity, some a little less. It would be a *group personality* that they were 'expressing'—a pattern imposed on them by means of education and the hypnotism of cinema, wireless, and press. Each one would, however, be firmly persuaded that it was 'his own' personality that he was 'expressing': just as when he voted he would be persuaded that it was the vote of a free man that was being cast, replete with the independence and free-will which was the birthright of a member of a truly democratic community.

Here, in this case, you get an individual convinced that he is 'expressing his personality': that he has a thing called a 'personality', and that it is desirable to 'express' it. He has been supplied with this formula, 'expressing the personality', as a libertarian sugar-plum. He has been taught that he is 'free', and that it is the privilege of the free man to 'express his personality'. Now, if you said to this man that he *had* no personality, that he had never been given the chance to have one, in any case, in the standardized life into which he fitted with such religious conformity: and secondly that he did not want to have a personality at all, really, and was quite happy as he was,—he would reply that you might be very clever and might think that you were funny, but that *he* was the best judge of whether he possessed a personality or not: that as he 'expressed' it every Saturday afternoon and evening and on Sundays, he probably knew more about it than you did; and that in consequence your gratuitous

49

assumption that he did not want one was absurd, as well as offensive. If he were a savage Robot, he might confirm this statement by directing a blow at your head.

The Art of Being Ruled, part 5, ch. 6

The radical nature of this analysis should not be overlooked. Any youngster fresh from his second meeting of the SDS or New Left group at his college would probably feel he knew all about how 'democracy' operated under such 'libertarian sugar-plums' as the one Lewis describes here. What he might not go on to add, as did Lewis, is the possibility that the good American or Englishman puppet or robot might, if pressed by such an analysis, decide to knock you on the head, although recent experience with New York hard-hat construction workers may have taught him differently. But it would be difficult for the ardent New Leftist to maintain as much detachment from that possibility as we feel in Lewis's response. *The Art of Being Ruled* looks back in its concerns, and sometimes its tone, to Arnold's *Culture and Anarchy*, except that Lewis has no such idea as culture to hold out as a shining hope. He is too aware of the possibility that when the labourer hears talk about culture he may reach for a handy club, if not for his revolver. So there is a good deal of built-in scepticism, a witty sense of recalcitrance with regard to the possibilities for doing good, helping men and women *really* to express themselves. Lewis's illiberalism, what some would call his anti-humanism, is found in the entertained possibility that maybe not all people can have personalities, at least if by personality is meant the kind of fierce, truly revolutionary individuality possessed by the true artist.

But whether it was the grinning Englishman with his famous sense of humour, or any puppet from any country expressing a group-self in the belief that it was his own per-

sonality, Lewis had no easy cure for the situation. In *Time and Western Man*, published a year after *The Art of Being Ruled*, he said that he had modified his views expressed in the earlier book, and that he now believed 'people should be compelled to be freer and more "individualistic" than they naturally desire to be, rather than that their native unfreedom and instinct towards slavery should be encouraged and organized'. The later book contains perhaps his most brilliant and extended polemic against what he calls the 'time-philosophy' as it was expressed particularly in the writings of Bergson, Spengler and Alfred North Whitehead. Lewis felt that this new 'organic' philosophy with its homage to immediate experience, its distrust of verbal explanations, its penchant for—in Whitehead's phrase—'taking time seriously', was against everything which he stood for as an artist: the common-sense world of static fully-rounded things, apprehended, painted and sculpted by someone in possession of his own self. Here Lewis takes on Bergson, Whitehead and the 'space-time' doctrines:

19

From a popular point of view, then, the main feature of the space-time doctrines (and with Bergson it was precisely the same thing) is that they offer, with the gestures of a saviour, *something* (that they call 'organism'! and that they assure us tallies with the great theory of Evolution—just to cheer us up!)—something *alive*, in place of 'mechanism': 'organism' in place of 'matter'. But the more you examine them ...the more you will feel that you are being fooled. For what the *benefit* to you, in this famous change from matter to mind, from 'matter' to 'organism', is going to be, it is very difficult to discover. For it is not *you* who become 'organic'; *you* have been organic all along, no one has ever questioned that. It is your tables and chairs, in a pseudo-leibnizian

animism, not you, that are to become 'organic'. As Professor Whitehead puts it, 'the things experienced and the cogniz-ant subject, enter into the common world on equal terms.' But something *does* happen to you as well—the 'you' that is the counterpart of what formerly has been for you a material object. You become no longer one, but many. What you pay for the pantheistic immanent oneness of 'creative', 'evolutionary' substance, into which you are invited to merge, is that you become a phalanstery of selves. The old objection to any pantheism, that it banishes individuality and is not good for the self, comes out more strongly than ever in the teaching of 'space-time'. So, as you proceed in your examination of these doctrines, it becomes more and more evident that, although it is by no means clear that you gain anything (except a great many fine phrases and exalted, mystical assurances of 'cosmic' advantages), it is very clear what you *lose*. By this proposed transfer from the beautiful *objective*, *material* world of common-sense, over to the 'organic' world of chronological mentalism, you lose not only the clearness of outline, the static beauty, of the things you commonly apprehend; you lose also the clearness of outline of your own individuality which apprehends them.

Time and Western Man, Book 2, part I, ch. 3

A few pages later he adds tartly : 'The valuable advantages of being a "subject" will perhaps scarcely be understood by the race of *historical objects* that may be expected to ensue.' To ensue, that is, if men give up their individualities, their 'natures', to the One Worldism of Whitehead's in which we must accept a metaphor of 'equal terms' to describe our relationships with things outside us. Lewis's objections to Whitehead, and other 'time-philosophers' are in the best sense self-ish; protective and conservative of what he is not willing to see Western Man give up without a fight.

He waged an analogous fight in *Paleface*, written as he

said to help the white man get over his inferiority complex, but really a critique of white men (like Sherwood Anderson and D. H. Lawrence) who sentimentalized the healing powers of blackness or redness, any skin-colour but white. This book was never published in the United States and it is interesting to speculate what might happen were it published today. As he stood up for the self in *Time and Western Man*, so in *Paleface* he eventually comes round to the following defence of laughter:

20

Today we should not give up our laughter: for the White Man knows how to laugh, and the Anglo-Saxon has a kind of genius for it. But we should develop another form of laughter. We should make a more practical use of this great force, and not treat it as an irresponsible, mischievous luxury. Other people, their habits, their faces, their institutions, are just as ridiculous as ours. It is a little *over*-christian to be the perpetual, 'dignified' butt! But it is no use at all for our laughter to be of that easy 'kindly', school-boy variety, that merely endears the people laughed at to the lookers-on. *We* are not laughed at in that manner. There is nothing of the advertisement-value of that kind of laughter in the Black Laughter or Red Laughter directed at us.

So let us get a point into our new laughter, if we are going to have it at all. Do not let us fear to hurt people's feelings by our laughter, since we may depend on it they will not spare ours. Nothing can help us so much as to develop this type of laughter.

Let the usual *Black Laughter*, or *Red Laughter*, directed at us, go on: but let it become a thing of the past for us to remain as its amiable, accommodating, and self-abasing butt.

We can even dispense with the musical arpeggios of

laughter itself : let us rather meet with the slightest smile all those things that so far we have received with delirious rapture—first, at all events, until we are sure of them. All this frantically advertised welter of ideas that pour over us from all sides, from nowhere, let us above all, at least meet *that* as it should be met. Do not let us spring up and prostrate ourselves every half-minute, as the latest ambassador arrives with News from Nowhere, with an auctioneer's clatter. Let us remain seated, the feminine privilege : let us smile sceptically, also the feminine privilege : let us insist upon every feminine privilege : let us be faultlessly polite, or rather over-polite, crudely polite : let us show this political tout, dressed up as a wise man from the East, that we have expected him, that we should only have been surprised if he had not turned up: that we hope he soon will go. That is the only way to treat the Thousand and One Magi and Chaldeans who successively rattle our knocker.

Paleface, Conclusion

The political tout dressed up as one of the Magi is of course the bearer of the latest system for instant salvation and we will be unable to resist him, whatever his message, if we tap our boundless reservoirs of white liberal guilt about everything on all occasions. As in the passage from *Tarr*, Lewis is asking for a different, a harsher and tougher kind of humour to replace the aimless grin of self-complacency or self-abasement still grinned by certain liberals today. When he assures us that other people's institutions are just as ridiculous as ours, that very remark is an example of the more 'practical' use of the laughter he encouraged. The remark speaks up for a democracy of institutions based on the assumption that none of them has the true and only recipe for political or personal salvation, nor that any race has a monopoly on virtue—Lewis might say that they were all equally vicious, a debatable point at the moment; but

there seems to me little to debate in his criticism of those writers who were ready at any moment to bang the drum loudly for any piece of News from Nowhere, or any nostrum or colour of skin not of course their own.

Lewis has been called a fascist, a reactionary, most innocently, a conservative; he himself variously referred to himself as a radical, a bit of a Bolshevist and other more complicated designations. It is surely true that his critical books are in one way or another conservative: of the self, of the 'objective, material world of common-sense' he prizes in *Time and Western Man*, and of the subjective common-sense which should be sceptically applied to revolutionary simpletons and slogans. But no appreciation of his sociological criticism should forget that he was also, in some ways first and foremost, a painter and that he never lost the plastic bias towards seeing things as they are. The following paragraphs give perhaps the clearest statement of his commitment as a visual artist:

21

The fundamental claim of the painter or sculptor, his fundamental and trump credential, is evidently this: that he alone gives you the visual fact of our existence. All attachment to reality by means of the sense of sight is his province or preserve. His art is in a sense the directest and is certainly the most 'intellectual', when it is an art at all. The word-picture of the writer is a hybrid of the ear and eye. He appeals to both senses. In his imagery he leaves you the emotional latitude almost of the musician. He says 'the dog bayed', and as you read it a ghost of a deep sound causes a faint vibration in your throat (you 'bay'), and a vague hound appears with bloodshot eye and distended neck in the murk of your consciousness. The painter paints you a dog baying: it is a new and direct experience. More pre-

cise and masterful, it is less fluid and partakes less of the emotional physical nature of any movement. The dog never bays, although it shows you the gesture of baying. Although evidently existing in our atmosphere, one of the attributes of such existence is wanting.

The 'Happy melodist unwearied, Forever piping songs forever new', of Keats, is only so happy because his pipe is soundless and because he has sacrificed the whole of his existence for the frigid moment of a sort of immortality. There is not one immortality, evidently, but several types, and this one is the painter's; a sort of death and silence in the middle of life. The death-like silence and repose, is one of the assets of the painter or sculptor. If pictures made a noise, like the statue of Jupiter Ammon or the figures at the approach to Samuel Butler's *Erewhon*, the unique character of the destiny of plastic art would be impaired.

No one has ever wept at the sight of a painting in the way they sometimes weep when they listen to music. You could not by showing people a picture of a battle cause their hearts to beat and their limbs to move, eyes to water, and stomach to turn round, as it is fairly easy to do by beating on a drum, and blowing into a fife. The respective physical effects of music and painting must always be insisted on in any attempt to arrive at a definite idea of the destiny of either of these arts. The coldest musician, even one who, like Schoenberg, appears to be writing a sort of musical prose, cannot help interfering with your body, and cannot leave you so cold as a great painter can. As you listen to music you find yourself dashing, gliding, or perambulating about : you are hurried hither and thither, however rhythmically; your legs, your larynx, your heart are interfered with as much as is the membrane of your ear. Whereas looking at Botticelli's 'Birth of Venus' would cause you as little disturbance of that sort as looking at a kettle or the Bank of England.

Wyndham Lewis on Art, 'The Credentials of the Painter'

In a sense this statement takes us back to where we began, with a consideration of Lewis's definition of the comic as things behaving as people. It would be comic indeed, that is, to have Botticelli's Venus yawn, stretch and give us a wink. On the other hand 'people' like Humph (in *Snooty Baronet*) or the good English fellow who thinks he is 'expressing his personality' every Saturday night and Sunday afternoon are not persons in the honorific sense Lewis wants to reserve for 'natures' as opposed to puppets. For Lewis to jump as he was constantly doing, from statements about art to statements about people or life, then back again, moving art-terms like 'static' or 'cold' into human realms where they point to different events, is an extremely risky business, and it won him a good deal of disfavour, some of it justified, much of it not. His laughter, the cultivated grimace of The Enemy as he self-styled himself, did not always and does not now strike many readers as admirable. For all the people who know D. H. Lawrence as a famous name, have read some of his books and are perhaps interested in his thought about the insufficiencies of white mental-consciousness, how many know what Lewis wrote about Lawrence, or can recall a moment when Lewis quotes a sentence from Lawrence's *Mornings in Mexico* on the virtue of Indian women ('the putting forth of all herself in a delicate, marvellous sensitiveness, which draws forth the wonder to herself')? What as we read along do we say at such a point in the narrative or argument? Lewis's response is to concentrate not on the woman but on her spouse: 'What would the Indian think if he heard his squaw being written about in that strain?— "delicate, marvellous sensitiveness".' And he answers his own question: 'He would probably say, "Chuck it, Archie!" in Hopi. At least he would be considerably surprised, and probably squint very hard, under his "dark"

brows, at Mr. Lawrence.' What in fact do some of the people who are written about in that strain today think of their enthusiasts? It is entirely possible that, if they had the chance, their response might be at least as colourfully negative as 'Chuck it, Archie' in Hopi. Here is an example of a moment in Lewis's cultural criticism where he seems to me to have the advantage in reality over the figure he criticizes, that advantage being gained not just through detachment or scepticism or practised applied laughter, but through a successful imagining of other possible human responses. What is there in Lawrence's rhapsody over the Indians beyond Lawrence's yearnings and projections of imagined vitalities where they *must* exist, so unlike England and himself? Are you all that sure they are *that* unlike us, asks Lewis's voice, and the spell is happily broken.

The most refreshing thing is that, for all his much-celebrated suspiciousness and at times over-righteous behaviour about his role as Enemy, scourge of God and terrorizer of all false revolutionary fashions and the latest *chic*, Lewis fully recognized he was playing a role which had its own vulnerabilities and amusing sides. To illustrate his capacities for detachment from self, from himself as Enemy, here are a few paragraphs from a newspaper article in which he lets the public in on what it feels like to be an Enemy:

22

The telephone is an important weapon in the armoury of an 'Enemy', a sort of deadly air-pistol. I don't know what I should do without the telephone.

After breakfast, for instance (a little raw meat, a couple of blood-oranges, a stick of ginger, and a shot of Vodka

—to make one see Red) I make a habit of springing up from the breakfast-table and going over in a rush to the telephone book. This I open quite at chance, and ring up the first number upon which my eye has lighted. When I am put through, I violently abuse for five minutes the man, or woman of course (there is no romantic nonsense about the sex of people with an Enemy worth his salt), who answers the call. This gets you into the proper mood for the day.

You then throw on a stately Stetson, at the angle that intimidates, thrust a cigar between your teeth, and swagger out into the street, eyeing all and sundry as if they were trespassing on the pavement.

You cruise round the West End of London on the look out for an Enemy, and when you meet one pour in a few broadsides of 'vitriol' or of 'invective' (you have, of course, provided yourself with bandoliers full of both) and pass on.

Perhaps you grapple and then board an East-bound bus (to get yourself back to the centre of the battlefield); if from its top you catch sight of an enemy, you lean out and give him a potted piece of your mind as you sweep past.

> *Wyndham Lewis on Art*, 'What It Feels Like
> to Be an Enemy'

The performance of this creative fantasy, right down to the stick of ginger and shot of Vodka, is as casual as one might wish; it suggests that behind all the outrage and polemic and ridicule Lewis employed so well there was a healthy and attractive sanity. Sanity of the sort that is also present in these rough and ready couplets from Lewis's single book of poetry, *One-Way Song*:

23

I knew you'd like the Enemy! He's the person
May pen in plastic fashion a new verse on
The Heldenleben and colossi's lot,
Or with his pen put penclubs on the spot.
He knows to live comes first. No bee in his bonnet
Outbuzzes any other that lands on it.
His balance is astonishing when you consider
He has never sold himself to the highest bidder,
Never has lived a week for twenty summers
Free of the drumfire of the camouflaged gunners
Never has eaten a meal that was undramatic—
Without the next being highly problematic.
Never succumbed to panic, *kaltes blut*
His watchword, facing ahead in untroubled mood.
He has been his own bagman, critic, cop, designer,
Publisher, agent, char-man and shoe-shiner ...
I was sure you'd like him and that was why I brought
 him—
It was a piece of luck it happened that I caught him.

<div align="right">'If So the Man You Are'</div>

Creative fantasy: persons

We referred just now to the portrait of a day in the life of an Enemy (and earlier to the Cab-Driver Test for 'fiction') as creative fantasy, a term which will be used to characterize Lewis's most imaginative rendering of persons and places. This chapter begins with some literary portraits of real people. Lewis painted and drew splendid portraits and sketches of Pound, Eliot, Edith Sitwell, two of which at least are visible at the Tate Gallery. As we have already seen to some extent, he also drew them in words, sometimes rather fiercely. The 'portraits' chosen here are more casual and relaxed, and the interest is in seeing how they begin with a 'real person' named T. E. Lawrence or Ronald Firbank and set about producing a figure in a situation that never quite was on sea or land the way it unmistakably is in Lewis's prose. It is the nature of the distortion which interests us and makes the figures memorable. From passages about persons we move on to ones in which some sort of landscape is the central focus, trying in each case to define the imaginative space in which events are taking place. But of course persons and landscapes cannot be separated; for example, what is going on in the following account?

24

One night I was sitting in this studio [in Holland Park]—
a little gloomily for things were not going any too well.
I had spent the last of my money and had not yet got the
hang of the art-game and such humble money-spinnings
as my simple wants prescribe. Outside the wind blew the
leaves of Holland Park up and down the street, and within
I sat before a fire, giving a companion the benefit of my
opinion of sundry aspects of life ...

A knock came at the door. The wind howled and blew
the blowsy leaves of Holland Park against the studio win-
dow. My companion and I looked at each other. There
was a second knock—a timid knock. I went to the door,
half opened it, and went outside on to the steps. These
led down to a locked gate. There was a small figure at
the bottom of the steps. There was only one way he could
have got there and that was over the wall.

This clearly must be a dun, I thought. That at eight
o'clock at night a tradesman's bully should scale my wall
and present his bill seemed to me to be pressing too far
the privilege of the creditor.

'Who might you be?' I enquired, not without a note of
sarcasm.

No reply came from the foot of the steps.

I descended the steps, a little truculently perhaps, and
stood beside the small and unobtrusive figure in a rain-
coat—hatless and it seemed to me furtive and at the same
time odd.

'Well,' said I. 'I await your explanation. Was it you
who knocked upon my door?'

'Yes,' muttered the stranger.

'I should like to draw your attention to the fact that
I rent these premises, that my gate is *locked*—which sig-
nifies that I do not desire visitors—and that you are
trespassing.'

'I know,' said this enigmatical person, in a low and gentle

voice, turning his head slightly to one side, as if the victim of a slight embarrassment—which did him credit and put me in a better humour.

'Well,' said I. 'Who are you, anyway?'

'I am Lawrence,' said he.

Now for some moments I had been thinking that for a dun he was on the quiet side. And no dun says, 'I am Lawrence,' like that, when you ask him who he is. I had heard, also that Col. Lawrence wanted to see me. Slowly it dawned on me who my visitor was.

Blasting and Bombardiering, part 4, ch. 8

Lewis goes on to confide in us that on this occasion Lawrence did *not* come in, though they got together at a later time. Whether he was invited in at all is not made clear. And indeed what did happen here anyway? Is this anecdote told to illustrate Lawrence's shyness, or his passion for anonymity, or his boldness in scaling walls he shouldn't be scaling? What about the cosy, depressed atmosphere conjured up by those blowsy leaves blowing about outside while Lewis and a companion sit before the fire? What does it mean that Lawrence of Arabia should intrude upon this atmosphere? And how does one know when Lawrence comes knocking at your door that it is in fact he and *not* a dun? Just ask him who he is, and when he answers quietly 'I am Lawrence' you will be sure you are not in the presence of a dun? Did Lewis really explain to Lawrence in full detail why the door was locked and what that meant about privacy, etc.? These questions do not need to be, cannot be answered. What they show is the extremely playful (played-up and underplayed at the same time) ambiguous nature of this evening visitation by a famous hero, and there is a teasingly fascinating tongue-in-cheek atmosphere about the whole presentation, perhaps endemic to Lewis's procedures as a memoir writer.

In the next example the tongue is even further in the cheek, to what exact effect it is even more difficult to say. Lewis and Eliot are visiting Paris where Eliot has been enjoined by Pound to get in touch with Joyce and deliver Joyce a package from Ezra. In due course Joyce and son arrive at Eliot's hotel; the package is sitting on a large table:

25

Joyce lay back in the stiff chair he had taken from behind him, crossed his leg, the lifted leg laid out horizontally upon the one in support like an artificial limb, an arm flung back over the summit of the sumptuous chair. He dangled negligently his straw hat, a regulation 'boater'. We were on either side of the table, the visitors and ourselves, upon which stood the enigmatical parcel.

Eliot now rose to his feet. He approached the table, and with one eyebrow drawn up, and a finger pointing, announced to James Joyce that *this* was that parcel, to which he had referred in his wire, and which had been given into his care, and he formally delivered it, thus acquitting himself of his commission.

'Ah! Is this the parcel you mentioned in your note?' enquired Joyce, overcoming the elegant reluctance of a certain undisguised fatigue in his person. And Eliot admitted that it was, and resumed his seat.

I stood up: and, turning my back upon the others, arranged my tie in the cracked Paris mirror—whose irrelevant imperfections, happening to bisect my image, bestowed upon me the mask of a syphilitic Creole. I was a little startled: but I stared out of countenance this unmannerly distortion, and then turned about, remaining standing.

James Joyce was by now attempting to untie the crafty housewifely knots of the cunning old Ezra. After a little he

asked his son crossly in Italian for a penknife. Still more crossly his son informed him that he had no penknife. But Eliot got up, saying 'You want a knife? I have not got a knife, I think!' We were able, ultimately, to provide a pair of nail scissors.

At last the strings were cut. A little gingerly Joyce unrolled the slovenly swaddlings of damp British brown paper in which the good-hearted American had packed up what he had put inside. Thereupon, along with some nondescript garments for the trunk—there were no trousers I believe—a fairly presentable pair of *old brown shoes* stood revealed, in the centre of the bourgeois French table.

As the meaning of this scene flashed upon my listless understanding, I saw in my mind's eye the phantom of the little enigmatic Ezra standing there (provided by our actions, and the position of his footgear at this moment, with a dominating stature which otherwise he scarcely could have attained) silently surveying his handiwork.

James Joyce, exclaiming very faintly 'Oh!' looked up, and we all gazed at the old shoes for a moment. 'Oh'! I echoed and laughed, and Joyce left the shoes where they were, disclosed as the matrix of the disturbed leaves of the parcel. He turned away and sat down, placing his left ankle upon his right knee, and squeezing, and then releasing, the horizontal limb.

Blasting and Bombardiering, part 5, ch. 4

The word 'enigmatic', also used in the passage about T. E. Lawrence, appropriately recurs in this one and describes the puzzled responses of a reader who has perhaps been hoping—in this chapter called 'First Meeting with James Joyce'—to have revealed some startling conversation between him and Lewis. Instead with much ceremony and fussing, we get the very gradual unwrapping of these old brown shoes. Again, we can ask many questions here:

Ezra Pound was playing a joke, yes? On Joyce? On Eliot and Lewis too? Was there some private association he or Joyce had with the shoes? Is a pair of old shoes the most inappropriate thing you could ever ask your friend (if he were Mr Eliot) to carry across the channel and present to another friend (if he were Mr Joyce)? Pound has prevailed: but in the midst of all this what is Lewis doing looking in the cracked Paris mirror and finding that he has 'the mask of a syphilitic Creole'? And after the faint 'Oh!' in that final paragraph what are we to make of Joyce's deliberate squeezings of his left ankle?

The fact is that, again, these questions cannot very well be answered. The pleasure lies in asking them, and a reader participates most vigorously in the performance—the literally creative fantasy—if he is willing to entertain these questions rather than resolve them. Somehow the passage coheres as if there were an inevitable connection between the various details that are so objectively unmemorable but, as experienced, unforgettable. So in the following portrait which might be titled, 'Meeting T. S. Eliot at Ezra Pound's', the way one thing fits in with another is mysteriously inevitable:

26

Well, Mr. Eliot swam into my ken in Ezra Pound's diminutive triangular sitting-room, in which all Ezra's social life was transacted, since, although really absurdly tiny, it was the only room in the Pound flat where there was any daylight.

In the base of the triangle was the door. As I entered the room I discovered an agreeable stranger parked up one of the sides of the triangle. He softly growled at me, as we shook hands. American. A graceful neck I noted, with what elsewhere I have described as 'A Gioconda smile'.

Though not feminine—besides being physically large his personality visibly moved within the male pale—there *were* dimples in the warm dark skin; undoubtedly he used his eyes a little like a Leonardo. He was a very attractive fellow then; a sort of looks unusual this side of the Atlantic. I liked him, though I may say not at all connecting him with texts Ezra had shown me about some fictional character dreadfully troubled with old age, in which the lines (for it had been verse) 'I am growing old, I am growing old, I shall wear the bottoms of my trousers rolled'— a feature, apparently, of the humiliations reserved for the superannuated—I was unable to make head or tail of.

Ezra now lay flung back in typical posture of aggressive ease. It resembled extreme exhaustion. (Looking back, I believe he *did* over-fatigue himself, like an excitable dog, use his last ounce of vitality, and that he did in fact become exhausted.) However, he kept steadily beneath his quizzical but self-satisfied observation his latest prize, or discovery—the author of *Prufrock*. The new collector's-piece went on smiling and growling out melodiously his apt and bright answers to promptings from the exhausted figure of his proud captor. His ears did not grow red, or I am sure I should have noticed it. Ezra then gave us all some preserved fruit, of which it was his habit to eat a great deal.

The poem of which this was the author had, I believe, already been published. But Pound had the air of having produced it from his hat a moment before, and its author with it simultaneously, out of the same capacious head-piece. He blinked and winked with contemplative conceit and contentment, chewing a sugared and wonderfully shrunken pear: then removed his glasses to wipe off the film of oily London dust that might have collected—but really to withdraw, as it were, and leave me alone with Mr. Prufrock for a moment.

Then, that finished, Ezra would squint quickly, sideways, up at me—'granpa'-wise, over the rims of his glasses. With

67

chuckles, and much heavy fun, in his screwed-up smiling slits of eyes, he would be as good as saying to me in the Amos and Andy patter of his choice: 'Yor ole uncle Ezz is wise to wot youse thinkin. Waaal Wynd damn I'se telling *yew*, he's lot better'n he looks!'

'Early London Environment' in *T. S. Eliot: A Symposium*

Eliot 'parked up' one side of the triangle, dimples in his skin; a remembered though misquoted famous line from some poem Lewis assures us he could make no sense out of; Ezra the captor, the excitable dog, passing out preserved fruit, chewing on his wonderfully shrunken pear and wiping his glasses; the final absurd Amos-and-Andy communication which it seems Pound did not *actually* say. How much of all this happened? The answer can only be that it didn't happen until 1948 when Lewis sat down to recall that far-off day back in Kensington. But, as with the Lawrence and Joyce passages, the air of casual confiding charms the reader; no stylistic fireworks, no huffing and straining for blockbusting metaphors or brilliant rhetorical effects. Partly this relaxation is appropriate to the quiet retrospections of memoir or appreciation; partly it marks a general diminishment of the noise level, the 'highly energized writing' of Lewis in the 1920s. There is however still plenty of energy, it may be agreed, and much of it seems expressive of the warmth and amused pleasure with which memory plays over the past and fantasy creates what we may like to think was implicit in the scene all along but which only the skilled painter in words can bring to life.

Here is one broad final touch to conclude this section and illustrate how creative fantasy about a person can have its affiliations which could pass as acceptable music-hall routine or burlesque exchanges involving the comedian

and straight man. Except that in this instance the comedian is Ronald Firbank, and Lewis—as usual in these acts, the 'objective' narrator who is just looking-on—conjures up a Firbank commensurate with his own novels:

27

Firbank is buried in Rome next to the grave of John Keats. I shouldn't like to have a grave next to his. If there's one place where one may, I suppose, expect a little rest, it is in the grave. And Firbank in his winding-sheet upon a moonlit night would be a problem for the least fussy of corpses in the same part of the cemetery. 'Thou still unravished bride of quietness!' I can imagine him hissing at Keats, 'come forth and let us seek out the tomb of Heliogabalus together shall us!' If there were only a Keats Society, I'd get up an agitation to have his grave moved.

From this you must not gather that I objected to Firbank. On the contrary, he seemed to me a pretty good clown—of the 'impersonator' type. Facially, he closely resembled Nellie Wallace. He seemed to like me—I had such relations with him as one might have had with a talking gazelle, afflicted with some nervous disorder.

In Stulik's one night I had dinner with him and a young American 'college-boy' who was stopping at the Eiffel Tower Hotel. The presence of the fawning and attentive Firbank put the little American out of countenance. He called the waiter.

'I guess I'll have something t'eat!' he announced aggressively.

'What will you have, sir?' asked the waiter.

'I guess I'll have—oh—a *rump-steak*.'

He pored over the menu: it was evident he felt that a rumpsteak would disinfect the atmosphere.

'Yessur.'

'Carrots,' he rasped out defiantly.

'Yessir. Carrots, sir.'

'Boiled pertaters.'

'Yessir.'

'What? Oh and er ...'

But with gushing insinuation Firbank burst excitedly in at this point.

'Oh and *vi-o-lets*!' he frothed obsequiously.

Reacting darkly to the smiles of the onlookers the college-boy exclaimed, but without looking at his cringing 'fan'—

'There seems to be a lot of *fairies* round here!'

And he sniffed the air as if he could detect the impalpable aroma of an elf.

Blasting and Bombardiering, part 4, ch. 5

Lewis does indeed make it clear that he didn't 'object' to Firbank, any more than he objects to the American impersonation of a college-boy who, even during the 1920s probably didn't refer to 'boiled pertaters' in that manner. The only kind of understanding revealed in this portrait of Firbank is skin deep; a delight in the clown's impersonation, down to the last perfect froth of violets or the aroma of an elf.

It should be added that there were moments in Lewis's writings where his great gifts as a creative fantasist were put to drastically misapplied ends. The most egregious example of such misconception was a book he wrote on Hitler in 1931. Adorned with a swastika on the cover and many words inside in praise of what the National Socialists were doing to clean up Germany, it reveals an arrogance of imagination and terrible simplicity of judgment that show the limitations of trying to treat all-too-human people as puppets, responsive to the strings of your own performing artistry. The book is out of print and likely to remain so; Lewis himself tried in a later book called

The Hitler Cult to redress his earlier praise. My own purpose in dwelling on the portraits of Lawrence, Joyce, Pound, Eliot and Firbank is to further the possibility that Lewis will be read and remembered for these funny, affectionate tributes rather than for the more blatant (and solemn) tribute to Hitler in which he went after a very strange god indeed.

Creative fantasy: places

Creative fantasy also describes the performance by which Lewis's novels put before us the spirits of various places. In the passages considered chronologically in this section an individual character—if there is one at all—is revealed to us by being set within a strange and memorable landscape or scene: the character is literally 'placed'. Lewis was fond of proclaiming himself a partisan of the eye, of space rather than time, the outside as opposed to the inside of things, and his graphic work makes clear how dedicated he was to rendering such tactile values. But rather than coming to these examples with a fixed notion of what he believed in or promoted, therefore what must be there in his fiction, let us work from the other way round and select some important and arresting scenic moments, then see what can be concluded from them individually and in sequence.

The earliest one is taken from Lewis's play *The Enemy of the Stars* which he first published in 1914 in *Blast*, the Vorticism showpiece-periodical:

28

THE YARD

The Earth has burst, a granite flower, and disclosed the scene.

A wheelwright's yard.

Full of dry, white volcanic light.

Full of emblems of one trade: stacks of pine, iron, wheels stranded.

Rough Eden of one soul, to whom another man, and not EVE, would be mated.

A canal at one side, the night pouring into it like blood from a butcher's pail.

Rouge mask in aluminium mirror, sunset's grimace through the night.

A leaden gob, slipped at zenith, first drop of violent night, spreads cataclysmically in harsh water of coming. Caustic Reckett's stain.

Three trees, above canal, sentimental black and conversational in number, drive leaf flocks, with jeering cry.

Or they slightly bend their joints, impassible acrobats; step rapidly forward, faintly incline their heads.

Across the mud in pod of the canal their shadows are gawky toy crocodiles, sawed up and down by infant giant?

The Enemy of the Stars

There is no reason why this could not go on and on, and once he gets used to it a reader does not balk at anything in particular as excessive. An answer to the question where are we located here would of course be in a wheelwright's yard (notice the stacks of pine, iron, etc.) but that would not be a very interesting answer since these 'emblems of one trade' are also emblematic of a 'Rough Eden of one soul'. Where is the canal located into which the night pours 'like blood from a butcher's pail'? A sophisticated answer might be, only in the line where those words are forced together through assertion and image. And how much is seen here? Can you see trees as 'sentimental black and conversational in number' or is the apprehension quite different from a visual one? In this energetic 'brilliant'

writing something forceful has to happen in every line; the reader is perhaps supposed to respond with a succession of impressed 'Ahs' but it is not clear that he can do much else. If shadows are 'gawky toy crocodiles, sawed up and down by infant giant' that is the way it is and so be it— we award the writer points for a good verbal stroke.

In *Rude Assignment*, Lewis's second memoir written in 1950, he refers to this early play (*The Enemy of the Stars*) as an attempt to show certain 'literary contemporaries' that writing could be as avant-garde as painting and sculpture. But he adds, 'It became evident to me at once, however, when I started to write a novel, that words and syntax were not susceptible of transformation into abstract terms, to which process the visual arts lent themselves quite readily.' This novel was *Tarr*, published in 1918 though written earlier, and revised thoroughly in 1928; as Lewis put it, it 'dragged me out of the abstractist cul-de-sac'. One of its most interesting passages, presenting Tarr and his soon-to-be lover, Anastasya, in the Luxembourg Gardens, was mostly added in the revised edition:

29

The inviolate, constantly sprinkled and shining lawns by the Lycée Henri Trois were thickly fringed with a sort of humanity, who sat facing them and their coolness as though it had been the sea. Leaving these upland expanses to the sedentary swarms of mammas and papas, Tarr and Anastasya crossed over beneath the trees past the children's carousels grinding out their antediluvian lullabies.

This place represented the richness of three wasted years, three incredibly gushing, thick years—what had happened to this delightful muck? He had just turned seventeen when he had arrived there, and had wandered in this children's outdoor nursery almost a child himself. All this

profusion had accomplished for him was to dye the avenues of a Park with personal colour for the rest of his existence. *No one*, he was quite convinced, had squandered so much of the imaginative stuff of life in the neighbourhood of these terraces, ponds, and lawns. So this was more nearly *his Park* than it was anybody else's; he should never walk through it without bitter and soothing recognition from it. Well, that was what the 'man of action' accomplished. In four idle years he had been, when most inactive, experimenting with the man of action's job. He had captured a Park!—well! he had spent himself into the earth, the trees had his sap in them.

He remembered a day when he had brought a newly purchased book to the bench there, his mind tearing at it in advance, almost writing it in its energy. He had been full of such unusual abounding faith: the streets around these gardens, in which he had lodged alternately, were so many confluents and tributaries of memory, charging in upon it on all sides with defunct puissant tides. The places, he then reflected, where childhood has been spent, or where, later, dreams of energy have been flung away, year after year, are obviously the healthiest spots for a person where such places exist: but perhaps, although he possessed the Luxembourg Gardens so completely, they were completely possessed by thousands of other people! So many men had begun their childhood of ambition in this neighbourhood. His hopes, too, no doubt, had grown there more softly because of the depth and richness of the bed. A sentimental miasma made artificially in Paris a similar good atmosphere where the mind could healthily exist as was found by artists in brilliant, complete and solid times. Paris was the most human city we had.

Tarr, part 5, ch. 7

In its combination of elegiac tenderness and mocking irony towards one's aspirations, this passage is the most

human one we have in Lewis's fiction before the mid 1930s. The prose has a measured elegance and stateliness quite distinguishable from some of the louder and more frenetic specimens previously encountered. The 'richness of three wasted years' is also 'delightful muck'; but it is necessary and healthful, Lewis says, to be a child and wander in a children's outdoor nursery, especially if the nursery happens to be the Luxembourg Gardens, or more generally, Paris. The privilege of entertaining and flinging away 'dreams of energy' is what the artist needs if he is to function well, as he once did in 'brilliant, complete and solid times'—three splendid words. Perhaps, though, the moment that marks this prose as (in the language of the Taxi-Cab Driver's test for 'fiction') 'something more than, and something different from' ordinary garden-variety fictionalese, is found at the beginning of the final paragraph where Tarr remembers bringing a newly-purchased book to the park to read, 'his mind tearing at it in advance, almost writing it in its energy'. The sentence possesses a complex truth, strikingly but naturally expressed through the notion of ferocious anticipation that 'tearing' brings, and through the blend of envy, impatience, frustration and joy with which we greet the new book that says what we know we can say better but haven't yet been able to say. There is also the sense that, as all of us have captured and possessed some place in our imagination and thereby humanized it for all our life, so we have an image, a remembrance of ourselves as powerful readers, a heroic vision of intellectual possibility and attainment. The passage is charged with feelings like these: and the spirit of place evoked through the Gardens and Paris is the spirit of memory 'charging in upon it on all sides'. Wordsworth would have understood it all very well, even though he might have been bothered by other things about Lewis.

In 1928, the same year as the revised *Tarr* appeared, Lewis published what was to be the first volume of a projected four-volume work. It was eventually titled *The Human Age* (parts two and three were published in 1955, part four was not yet written when Lewis died) but the first section, which stood alone for nearly thirty years, was called *The Childermass* and begins in the following manner:

30

The city lies in a plain, ornamented with mountains. These appear as a fringe of crystals to the heavenly north. One minute bronze cone has a black plume of smoke. Beyond the oasis-plain is the desert. The sand-devils perform up to its northern and southern borders. The alluvial bench has recently gained, in the celestial region, upon the wall of dunes. The 'pulse of Asia' never ceases beating. But the outer Aeolian element has been worsted locally by the element of the oasis.

The approach to the so-called Yang Gate is over a ridge of nummulitic limestone. From its red crest the city and its walls are seen as though in an isometric plan. Two miles across, a tract of mist and dust separates this ridge from the river. It is here that in a shimmering obscurity the emigrant mass is collected within sight of the walls of the magnetic city. To the accompaniments of innumerable lowing horns along the banks of the river, a chorus of mournful messages, the day breaks. At the dully sparkling margin, their feet in the hot waves, stand the watermen, signalling from shore to shore. An exhausted movement disturbs the night-camp stretching on either side of the highway—which when it reaches the abrupt sides of the ridge turns at right angles northward. Mules and oxen are being driven out on to the road: like the tiny scratches of a needle upon this drum, having the horizon as its

perimeter, cries are carried to the neighbourhood of the river.

The western horizon behind the ridge, where the camp ends inland, but southward from the highroad, is a mist that seems to thunder. A heavy murmur resembling the rolling of ritualistic drums shakes the atmosphere. It is the outposts or investing belt of Beelzebub, threatening Heaven from that direction, but at a distance of a hundred leagues, composed of his resonant subjects. Occasionally upon a long-winded blast the frittered corpse of a mosquito may be borne. As it strikes the heavenly soil a small sanguine flame bursts up, and is consumed or rescued. A dark ganglion of the bodies of anopheles, mayflies, locusts, ephemerids, will sometimes be hurled down upon the road; a whiff of plague and splenic fever, the diabolic flame, and the modal obscenity is gone.

The Childermass, ch. 1

Unlike the Luxembourg Gardens excerpt from *Tarr*, one is not tempted to say very much about these paragraphs from *Childermass*. This is so partly because the narrator has effaced himself, pretending that he is merely describing a scene right down to the kind of limestone in the ridge and the various sorts of insects who sometimes are hurled down on the road. Yet in another sense all this specification is that on which science-fiction or romance lives. The first sentence tells us that the plain on which the Magnetic City lies is 'ornamented' with mountains. Lewis's task is to adorn, ornament and splendidly trick out a city the like of which was never seen before—a landscape beyond the frontiers of the mind. The reader must be in awe of the landscape, made aware that he is on the verge of something strange beyond his capacities for acceptance, prepared even for some real metaphysical dread. Compared to 'The Yard' section from *The Enemy*

of the Stars the opening of *Childermass* calls less attention to itself, since it has no need to stun the reader with a piece of brilliant imagery in each sentence. There is instead an impressive cumulative effect that quietly builds up as the scene begins to form itself (as it were) block by block. We notice syntactically that in a typical sentence a noun does something ('The city lies in a plain', the 'sand-devils perform', 'the day breaks') and that is all there is to it. A reader who picked this book up in his lending library, hoping for a good read and to have his attention drawn by an ingratiating narrator who promised delights to come, would probably put it back in rather a hurry; and indeed Lewis felt that this kind of philosophical fantasy should not be understood as having much to do with 'fiction'.

On the other hand *The Revenge for Love*, the book that most people now agree is Lewis's best novel might immediately interest the casual browser if he opened to page one and was plunged into this:

31

'Claro,' said the warder. 'Claro hombre!' It was the condescension of one caballero to another. His husky voice was modulated upon the principle of an omniscient rationality. When he spoke, he spoke from the bleak socratic peak of his wisdom to another neighbouring peak —equally equipped with the spotless panoply of logic. Deep answered to deep—height hurled back its assent to height! 'Claro, hombre!' he repeated, tight-lipped, with the controlled passion of the great logician. 'We are never free to choose—because we are only free once in our lives.'

'And when is that?' inquired the prisoner.

'That is when at last we gaze into the bottom of the

heart of our beloved and find that it is false—like everything else in the world!'

If one looks at this opening superficially it can be mistaken for a highly dramatic introduction promising a gripping tale with plenty of action—already we have the warder and the prisoner arguing about what seem to be profound moral issues. But simply to read it that way neglects the fact that the narrator's irony has also been brought into play with remarks about the 'bleak socratic peak of his wisdom' and 'spotless panoply of logic', so that the sententiousness of 'We are never free to choose ...' has something else than the ring of truth. And we are not surprised when after a few more exchanges between jailer and prisoner we encounter more narrative comments:

There were two crashes in rapid succession, a third, and then an outbreak of demoniacal cries. The Andalusian evening shed down its brilliant operatic light upon the just and the unjust alike. At a long table in the centre of the large concreted patio sat a dozen unjust men. Twelve of the most unjust in Spain, at the moment. They were unsuccessful politicos. They had been caught red-handed, with arms in their hands. Now they were awaiting trial—while other politicos, those who had triumphed over them, disputed in the Cortes Constituentes, Ateneo, and elsewhere as to what was the best thing to do with them—whether it was a case for the firing-squad or for a magnificent Spanish pardon—should they be convicted, when at last they were brought to trial. They played cards, sweated and spat. Their furious shouts, harshened by extreme catarrh, as they crashed Joker and King down upon the table, alarmed the pigeons patrolling the skyline of Baltic-blue over their heads—who made themselves into perambulating fans, to receive the coolness of the evening breezes into

their overheated wing-pits, their button eyes cocked to-
wards the remote sierra, from whence the coolness came
in irregular bursts of gently-flowing air.

The Revenge for Love, part 1, ch. 1

Again, what might be only sententious evocation of the
just and the unjust is something more because of the joke
about how it is these twelve disciples are the most 'unjust'
ones (that is, unsuccessful) in Spain at the moment. Such
all-too-human jokes about a less than heroic situation are
set off by the reminder that they exist in a wider, perhaps
more vital landscape where pigeons cock their button eyes
towards 'the remote sierra' and where the 'Andalusian
evening' sheds its 'brilliant operatic light' on what may be
either comic opera or something else. In other words one's
literary expectations, on the basis of the first few para-
graphs of this book, are rather complicated, impossible to
formulate in a neat label. The book could and does go
in lots of directions, could and does speak to us through
different kinds of narrative appeal, and the introductory
landscape must be ambiguous enough to serve as an ade-
quate indication of possible appeals.

No such ambiguity is present in the scene of our final
extract, a room in the Hotel Blundell, Momaco, Canada
where the hero of Lewis's late novel *Self Condemned* lived
with his wife for three years during the Second World
War. The first part of this novel has shown the events
leading to René Harding's decision, on the eve of war, to
leave England, give up his job as a historian and forcibly
eject himself from the past—his own and England's. Now
at the beginning of part 2 we are introduced to a new
environment:

32

The Room, in the Hotel Blundell, was twenty-five feet by twelve about. It was no cell. It was lit by six windows: three composed a bay, in which well-lit area they spent most of their time—René sat at one side of the bay, writing upon his knee on a large scribbling pad. Hester sat at the other side, reading or knitting or sleeping ...

It was René's habit to place an upended suitcase upon a high chair and drape it with a blanket. He stood this between his wife and himself, so blotting her out while he wrote or read. He could still see, over the crest of this stockade, a movement of soft ash-gold English hair, among which moved sometimes a scratching crimson fingernail. This minimum of privacy, this substitute for a booklined study, was all he had for three years and three months— to date it from the sailing of the Empress of Labrador from Southampton.

In summer René lowered the centre blind to shut out the glare. At present it was December, and another glare, that of the Canadian snow, filled the room with its chilly radiation. There was a small stack of books upon a chair to the left of him; he wrote in silence, hour after hour, dropping each page, as it was completed, into a deep, wooden tray on the floor at his side.

They never left this Room, these two people, except to shop at the corner of the block. They were as isolated as are the men of the police-posts on Coronation Gulf or Baffin Bay. They were surrounded by a coldness as great as that of the ice-pack; but this was a human pack upon the edge of which they lived. They had practically no social contacts whatever. They were hermits in this horrid place. They were pioneers in this kind of cold, in this new sort of human refrigeration; and no equivalent of a central heat system had, of course, as yet been developed for the human nature in question. They just took it, year after year, and like backwoodsmen (however unwilling) they

had become hardened to the icy atmosphere. They had grown used to communicating only with themselves; to being friendless, in an inhuman void ...

They must vegetate, violent and morose—sometimes blissfully drunken, sometimes with no money for drink —within these four walls, in this identical daily scene— from breakfast until the time came to tear down the Murphy bed, to pant and sweat in the night temperatures kicked up by the radiators—until the war's end or the world's end was it? Until they had died or had become different people and the world that they had left had changed its identity too, or died as they had died. This was the great curse of exile—reinforced by the rigours of the times—as experienced upon such harsh terms as had fallen to their lot.

Self Condemned, part 2, ch. 12

Sentence after sentence begins in an undistinguished way with 'They had' 'They were' or 'They must'. Read aloud, the rhythms do not captivate the ear, the sentences often feel abrupt, even lurching, in their movement from one to the next. Whatever metaphors are employed—comparing the 'cold' of their human isolation to the cold of an ice-pack—are thoroughly explained and developed so that no one could miss them: we go on to hear about 'human refrigeration' and the 'icy atmosphere'. There is very little humanizing of experience in the flat, rather toneless and harsh use of language which sets forth all the facts and only the facts as relevant. For if what is to be portrayed is an 'inhuman void', then certain kinds of verbal pleasures and performances must be denied himself by the narrator. He must, compared to the performers in previous scenes, make himself relatively chaste in order to say what has to be said. This does not mean that what we have been calling 'creative fantasy' has suddenly been

rejected as out of character; since to make a dismal hotel-room into an adequate symbol for the inhuman void explored in *Self Condemned* demands as many creative resources as are employed in setting a scene outside Heaven, in the Luxembourg Gardens or the Andalusian twilight. To contrive images by which the glare of light is shut out, other people are excluded and even one's wife must be blotted out by an upended suitcase with a blanket thrown over it, is for Lewis to use the resources of fantasy in a new and disturbing way, as a response to the pressures of felt life rather than the clever manipulation of words. It is a long way from the room in the Hotel Blundell back to 'The Yard' forty years before where night poured into a canal like blood from a butcher's pail. The change in style is expressive of Lewis's attitude towards other people and the world-scene in which they perform for each other.

Visionary gleams

Lewis proudly referred to himself as an 'eye-man' and took great pains to tie in his theory of satire with the hard, classical, 'external' approach to materials, to the outsides rather than the insides of things, to space rather than to time. His most extended formulation of this theory is found in a pamphlet titled *Satire and Fiction* written as a polemical defence of *The Apes of God*, then eventually incorporated into a sort of criticism-advertisement of himself in *Men Without Art*. There he claims that 'the great opportunity afforded by narrative-satire for a *visual* treatment is obvious. To let the reader "into the minds of the characters", to "see the play of their thoughts"—that is precisely the method least suited to satire.' Since in that book Lewis went on, provocatively, to equate satire with realism, he did not leave much distinguished work for non-satirical fiction to do. So far we have encountered a number of 'satirical' passages (for example, the description of Hobson in *Tarr*, or Humph in *Snooty Baronet*, or Edith Sitwell in the letter) where something—a character, a puppet—is brought before our eyes, made to dance and to perform according to his or her particular bag of tricks or tics; then à la Thackeray in *Vanity Fair*, it becomes time for the puppet to be put back into the box. Lewis did not go so far as to wholly excoriate telling it

from the inside—a method that in their different ways most of his contemporaries (Joyce, Virginia Woolf, D. H. Lawrence) had committed themselves to. But the frequent ineptness of its use drove him perhaps to the other side; and though he allowed that the internal method was good for presenting the thoughts of babies or animals or idiots, or for momentary comic relief, it had otherwise little value.

Yet what a writer says need not and probably cannot accurately reflect what he is in fact practising in his own art. Our final selections point to some important moments in Lewis's fiction, and his non-fictional writings as well, where what is being told is as much from the 'inside', as internal as one would expect to find in any traditional novel about a consciousness.

If, as Lewis always insisted, this narrative procedure is the one *least* suited for satire, then 'satire' will no longer be an adequate term for characterizing what goes on in his fiction. In all these passages some kind of important *seeing* is taking place, and to understand them we must see something ourselves which we have not seen before. But the seeing is more inward, more speculative, more profound, than the way in which our eyes were drawn to the spectacle, say, of Humph's enormous chin.

In the first passage Tarr meditates upon the meaning of a recent incident in his experience: he has been dogging the footsteps of a violent German art-student, Otto Kreisler, and competing with him for the favours of a woman. At a certain point Tarr goes to Kreisler's rooms, teases him, and eventually leaves when Kreisler brandishes a dog-whip at him and threatens him with reprisals:

33

With the part he had played in this scene Tarr was ex-
tremely dissatisfied. First of all, he felt he had withdrawn
too quickly at the appearance of the whip, although he
had, in fact, commenced his withdrawal before it had
appeared. Then, he argued, he should have stopped at the
appearance of this instrument of disgrace. To stop and
fight with Kreisler, what objection was there to that, he
asked himself? It was to take Kreisler too seriously? But
what less serious than fighting? He had saved himself from
something ridiculous, merely to find himself outside Kreis-
ler's door with a feeling of primitive dissatisfaction.

There was something mean and improper in everything
he had done, which he could not define. Undoubtedly he
had insulted this man by his attitude, his manner often
had been mocking; but when the other had turned, whip
in hand, he had—walked away? What really should he
have done? He should, no doubt, having humorously insti-
tuted himself Kreisler's keeper, have humorously struggled
with him, when the idiot became obstreperous. But at that
point his humour had stopped. Then his humour had limi-
tations?

Once and for all no one had a right to treat a man as
he had Kreisler and yet claim, when turned upon, im-
munity from action on the score of the other's imbecility.
In allowing the physical struggle any importance he
allowed Kreisler an importance too: this made his former
treatment of him unjustified ...

The parallel morals of his Bertha affair and his Kreisler
affair became increasingly plain to him. His sardonic dream
of life got him, as a sort of quixotic dreamer of inverse
illusions, blows from the swift arms of windmills and
attacks from indignant and perplexed mankind. But he
—unlike Quixote—instead of having conceived the world
as more chivalrous and marvellous than it was, had con-
ceived it as emptied of all dignity, sense and generosity.

The drovers and publicans were angry at not being mistaken for a legendary chivalry, for knights and ladies! The very windmills resented not being taken for giants!—The curse of humour was in him, anchoring him at one end of the see-saw whose movement and contradiction was life.

Tarr, part 5, ch. 8

This is a respectable enough passage of psychological analysis, self-questioning and self-laceration of the sort Lewis himself was familiar with mainly through his early reading of Dostoevsky. But there is nothing flabby or muddled or formlessly fluid about the passage; one feels the full resources of English are being used, that seriousness and high wit combine on excellent terms as they should in the reflections of a character—or his creator—endowed with what Tarr calls 'the curse of humour'. Such a moment of self-recognition and self-definition does not lead inevitably to any particular further action, or indeed to any action at all; one may emphasize 'curse' or 'humour' but at all events the hero is left on the literary end of the see-saw, with 'life' somehow in the see-saw's 'movement and contradiction'. It is good to have seen what Tarr has seen, regardless of what happens next; and in fact the novel does not go on to do justice (however that could be done) to the momentary insight of its hero.

In *The Revenge for Love* more than any other of his novels Lewis does impressive justice to the insights his heroine attains. And the very fact of a heroine whose mind is taken seriously distinguishes it from Lewis's other fiction. In the book Margot Stamp's attempt to protect her husband, Victor, from the world of duplicity and betrayal, the public man's world of politics—art-politics and the other kind—is doomed to failure. As they become ever more deeply implicated in a scheme which will end in violence

and death, Margot grows increasingly aware of how things go together. The following opening to a chapter presents her beside a mountain stream in Spain, preparing to bask in nature and do a bit of reading in Ruskin:

34

Margot lay upon the bank of a mountain stream, and gazed with a look of uneasy surprise at the playfulness of its waters. Power, elasticity, brightness: she could not have believed that the high spirits of these liquids and the grandeur of these stones could disturb a casual visitor, who had brought herself up on *The Excursion*; for whom nature was an open book. And yet she observed the incessant sport of the waters, as they poured in and out of the rocks, in their delicious obstacle race, with a mild aversion. At this placid health of sunlit nature she peered with a puzzled attention, her look suggestive, at once, of blank astonishment and involuntary reproach. To so bound and to so plunge, and to make such a jolly noise, as you went, struck her, one would have said, as peculiar and vaguely not *comme il faut*. There was a definite relish of wide-eyed, breath-taking scandal in her gaze—which mildly and sportively demanded enlightenment; but, more than that, which seemed pressing nature to give an immediate account of herself . . .

Under different circumstances, however, the behaviour of these jolly liquids, the phlegmatic grandeur of these chaotic stones, would have called forth other responses; all would have passed off quite differently had her mind not been obsessed with the actors, for whom these pastoral sets were the incongruous backgrounds, and if she had not been part of this agony of men. It was Victor who was her *nature* now; and 'wild nature' too, at that. So the company of nature—all the blatant bustle of these liquids and gases, and the chilly festivity of the organic bodies

attached to them, propelled upon wing, foot, fin—did not recommend itself to her, greatly to her surprise. Though was that to be wondered at, seeing that it jazzed around her breaking heart, so that she was astonished, if not almost scandalized.

The Revenge for Love, part 7, ch. 2

This vision is intense enough to express itself through the play of 'nature', through the critically detached, somewhat lordly characterization of the 'blatant bustle of these liquids', or the 'chilly festivity' of organic life that Margot as a woman in love with a man in trouble cannot detachedly appreciate. What is conveyed by the passage, and felt more strongly when one has read the chapters preceding it, is conveyed fully and robustly from the 'inside', in so far as Lewis is perfectly serious about sustaining the illusion of a person thinking, struggling, rejecting—as at the end of the chapter Margot rejects nature and Ruskin, leaving her book beside the stream to rejoin the life of human nature. But it is as much characterizing from 'outside', since Lewis denies himself no verbal means of making Margot's plight and her realization of it something that occurs before our eyes as we read along. The range of tone may perhaps be suggested by that phrase from the final sentence about how nature 'jazzed around her breaking heart' which both means that her heart is indeed breaking, as the hearts of romantic heroines are slated to, but that there is room in describing the break to use an unromantic, low term like 'jazzed'.

These two passages from *Tarr* and *The Revenge for Love* might be enough in themselves to suggest that both before and soon after Lewis's description of himself as a cold satirist, devoted to setting down only the outside of people, he wrote novels whose most significant activity was in contradiction to that description. But it is in two

books published just before his death that one feels most strongly how far from any kind of 'satirist' this novelist had become. *Self Condemned* is a novel about a hero, in many ways like Lewis, in other important ways unlike him (not being a novelist, for example) who emigrates with his wife to Canada during the Second World War. Near the close of the book the hero's wife commits suicide and her reality is then brought home to the protagonist in a number of ways; this excerpt expresses one:

35

He had gone to bed, after listening to the radio for two hours or more. Buffalo N.Y. was only a few miles away, and that was the station in to which he always tuned. 'Henry Aldridge', that splendid satire on the American schoolboy, was part of the programme. One of the things which had lightened the burden of their life at the Hotel Blundell had been precisely this radio-serial. As he lay on his bed, listening to the whining voice, full of a dry cunning, of Homer Brown; to the tremulous and querulous appeals of the hero; and to the ironic expostulation of Aldridge Senior, massively resigned at having given birth to such a son—absorbed in this wonderful entertainment, without realizing it, he had slipped back into the years of evenings passed in the Room, where Hester and he were enabled to forget the ghastly isolation and boredom of their lives. Nothing so much as the American radio, with all its wonderful gusto, the many sidedness of its interests, provided the necessary anaesthesia. There was one moment at which he forgot where he was, and it was his impulse to turn to Hester, to share with her the joy of some quip of Schnozzle Durante. It was at that point that he realized what had been happening, and that he had allowed himself to be led into a past where the living Hester was unavoidably to be encountered. But *after* that, and quite

consciously, he gave himself up to the retrospective enjoyment of the warm comfort of this shabby room in the Blundell Annexe, the zero weather outside, and the wonderful companionship of this woman he had shared so much with, and with whom he would soon coagulate in the pneumatic expanses of the Murphy bed.

Self Condemned, part 3, ch. 33

No matter that next day in the paragraph which follows this one the hero expresses a less sympathetic attitude towards his dead wife; the point is that in a sense this passage needs no commentary or analysis. Anybody who has read the book up to chapter 33 understands perfectly well what is going on here, especially in view of previous scenes of delighted listening to American radio comedians in between dismal war bulletins. But remembering some of our earlier excerpts from high-powered patches of Lewisian prose, how far we have come when we encounter a phrase such as 'the wonderful companionship of this woman he had shared so much with'! It is hardly any overstatement to say that for much of his writing career Lewis would not have been caught dead using such a common group of common words to describe anything. Some readers feel that the stylistic change in the late novels is to be applauded; others find them a falling off from earlier brilliance. The thing to note is that the reek of the human is very much about these last books, and that Lewis moderated his linguistic brilliance accordingly. What better phrase then than 'the wonderful companionship' to identify something you shared with your wife?

The passage from *Self Condemned* is not chosen to suggest that in his final work Lewis eschewed all spectacle in his language and made it plain and bare. But language no longer acts as an object of interest in itself, somehow

apart from whatever person or event it is presenting. Our last fictional example occurs at a crucial moment near the end of *Malign Fiesta*, part 3 of Lewis's unfinished four-part *The Human Age*. The hero, James Pullman, has been working for the Devil, Lord Sammael, and together they have set up a sort of institute for Fallen Angels, humanizing them, making the eternal more like life. But at a certain point God will have no more of this and sends Soldiers of Heaven to attack Angeltown and to carry off Pullman for the trial in which his final disposition would be determined:

36

A heavy hum in the air attracted Pullman's attention, it was a very unusual vibration. He looked up and saw the entire sky blotted out by a solid mass of angels—individually quite small, they were some distance away. There was something resembling the transparent about this filmy host, in the main very light, with pale blue, and crimson, and dark elongated smudges, also transparent. They were so densely packed that there must have been millions of them. There, towards the top, was a small rather whiter figure: it was the core of the composition, for it was extraordinarily *composed*, this aerial army, reminiscent of the Paradiso of Tintoretto; or better still, of a pastiche of Tintoretto painted by El Greco.

It was then he realized that this was not a parade of angels from the manufacturing town and so on, there were far too many. These were literally millions of glittering points, the swords and armaments of the soldiers of Heaven. *That was God he was looking at, it must actually be He, so intensely bright, and more. Oh it must be He.* As this realization came to him, and it came with the force of a very high wind, without moving from his posi-

tion he shook intensely from head to foot. The core of him, the inner being, which normally extended for the full length, shrank and shrivelled. It was as if a small animal was rushing up and down inside him, looking for a place to conceal itself.

Automatically he lowered the other knee, as if he were kneeling in prayer; and he actually began to pray, not looking any longer, however, at the small white figure which he recognized so far away as the mysterious personality into whose incredible ears his prayers somehow found their way.

The Human Age, part 3, ch. 19

Pullman looks at the heavenly host; so does the reader. What Pullman sees is that his prayers have been answered, incredible as it seems. But he also sees as Lewis the painter sees, and his eye moves to the small whiter figure at the 'core of the composition, for it was extraordinarily *composed*'. And it is at this point in the book where Pullman, who through many pages has remained extraordinarily composed himself for one in dangerous circumstances, is suddenly shaken intensely to his own core, loses his own composition as a human and prepares by kneeling to be carried off to heaven and the rest of the story Lewis never was permitted to write.

In the passage quoted at the beginning of this section from *Tarr* the hero looked inward and analysed his situation as caused by what he termed 'the curse of humour whose movement and contradiction was life'. It is interesting then that in the final paragraphs of what we may think of as Lewis's last significant book (although in fact an unsatisfactory novel *The Red Priest* was published after *The Human Age*) that contradiction is perhaps finally to be resolved, the curse removed from Pullman (a writer himself) as he moves towards the Divine:

37

Pullman rose, and found himself alone. But through the window he saw a bright cloud, like the advance across the sky of an insect mass. It was the Heavenly army surrounding the position of Angeltown and the house which was now his residence. He shivered, he knelt down beside a massive chair, and began a prayer to God, tears in his eyes.

The light blazed outside. An ocean of light seemed to have settled down around the lair of the lord Sammael —who, Pullman thought, would use that telephone no more. But prophecies affecting the lord Sammael applied also to him. And now he drew himself up upon the armchair and began thinking about his partisanship, regarding the Human Age in contrast to the Divine Age. At that moment he knew that he should never have assisted at the humanization of the Divine—because he was now in the divine element.

While he was developing a plan of conduct for a mind turning towards the Divine, the flat door burst open and two huge White Angels rushed into the room. He had only time to note that they were quite different from the White Angels who so far had paid him visits, that they were very tall, at least six inches above six foot, from their helmets downwards reminiscent of Roman soldiery, clanking as they walked with a profusion of armament. Their faces had the dazzling pallor of all those belonging to the Heavenly service; both had large grey eyes, the expression of which was not unfriendly, though they had the knitted intensity that came down in a line between the brows. But this was a momentary appraisal. For the first thing he knew was that these two figures had sprung at him, and lifted him bodily out of the chair. There was a harsh whisper in his ear. 'No harm will come to you.' Pullman had in his nostrils a smell of leather and of polished brass. He fell into a kind of unconsciousness.

With a great sound of martial clanking and with the thudding of their feet, he was borne quickly out of the room. He thought of nothing except God, a thought both felicitous and partaking of the muscular nature of this forced transport. As he passed through the door he could hear the telephone ringing, and Borp's voice as he answered it. He imagined his servant saying, 'Mr. Pullman is being carried away by two of God's soldiers.'

The Human Age, part 3, ch. 19

For all the finality of this, a prayer to God, tears in the eyes, the Divine element, it might be noticed that the final sentence consists of a very human piece of wit.

Epilogue

Most of Lewis's final works in the 1950s were written when he was nearly or totally blind, and aside from whatever feelings one has about such a situation, it was a particularly significant one for Lewis to endure, since he had spent so much of his life as a writer and plastic artist celebrating the virtues of the eye and the surfaces of things. Now, deprived of all these virtues, so much the more the celestial light had to shine inwards, and the retrospectiveness of *Self Condemned* or the divine preoccupations of *The Human Age* can be seen to have a personal reference. It is appropriate that the concluding selection should be a comment on this loss of sight and whatever gains of insight accompanied it. The following paragraphs are taken from an article Lewis wrote for the *Listener* for whom he had been reviewing various artists and gallery shows. 'The Sea Mists of the Winter' is notable for its peculiarly Lewisian combination of sardonic mockery—here self-mockery—and a kind of grim high spirits, if that can be imagined. We have noticed the combination before but it is never more exhilarating and moving than here :

38

Sometimes I am still at large solo, though increasingly rarely. I may go out, for instance, and some twenty yards away look for a taxicab. In these cases I will stand upon the edge of the pavement, calling imperiously 'Are you *free?*' to owner-drivers, who probably observe me coldly from behind their steering wheels as if I were the Yonghi-Bongi-Bo. I signal small vans, I peer hopefully at baby-trucks. At length I get a response. It *is* a taxi! But I assure you that it is one thing to hail a taxi-cab, another to get into it. This is quite extraordinarily difficult. I try to force my way in beside the indignant driver. He or I will open a door. But as I see everything so indistinctly I attempt to effect a passage through the wood of the door itself, in Alice Through the Looking Glass fashion, rather than take advantage of the gaping hole in the side of the taxi produced by the opening of the door. It is with a sigh of relief that I at last find my way in, after vainly assaulting the stationary vehicle in two or three places ...

The failure of sight which is already so advanced, will of course become worse from week to week until in the end I shall only be able to see the external world through little patches in the midst of a blacked out tissue. On the other hand, instead of little patches, the last stage may be the absolute black-out. Pushed into an unlighted room, the door banged and locked for ever, I shall then have to light a lamp of aggressive voltage in my mind to keep at bay the night ...

This short story of mine has the drawback of having its tragedy to some extent sublimated. Also, we have no ending. Were I a dentist, or an attorney I should probably be weighing the respective advantage of the sleek luminol, or the noisy revolver. For there is no such thing as a blind dentist, or a blind lawyer. But as a writer, I merely change from pen to dictaphone. If you ask, 'And as an *artist*, what about that?' I should perhaps answer, 'Ah, sir, as to the

artist in England, I have often thought that it would solve a great many problems if English painters were born blind.'

And finally, which is the main reason for this unseemly autobiographical outburst, my articles on contemporary art exhibitions necessarily end, for I can no longer see a picture.

'The Sea Mists of the Winter'

Select bibliography

REFERENCE LIST OF WYNDHAM LEWIS'S WORKS

Novels
Tarr (Written 1914, published 1918, revised ed. 1928). Available as a Jupiter Book, Calder & Boyars, 1968.
The Apes of God (1930). Available in Penguin Books, London and New York, 1965.
Snooty Baronet (1932). Never reprinted.
The Revenge for Love (1937). Reprinted Methuen, 1952 and Henry Regnery, Chicago, 1952. The American edition is still in print.
The Vulgar Streak (1941). Never reprinted.
Self Condemned (London, 1954, Chicago, 1955). American paperback edition available in Gateway Books, Henry Regnery, 1965.
The Human Age Part One: *Childermass*, originally published 1928 as *The Childermass*. Reprinted and retitled 1956. Available as a Jupiter Book, London, Calder & Boyars, 1966.
 Parts Two and Three: *Monstre Gai* and *Malign Fiesta*, published 1955. Now available in Jupiter Books, Calder & Boyars, 1966.

Short Fiction
The Wild Body (1927). Never reprinted.
Rotting Hill (1951). Out of print.

Sociological, Philosophical, Literary Criticism
The Art of Being Ruled (1926). Never reprinted.
Time and Western Man (1927). Available as Beacon paperback, Boston, 1957.
Paleface (1929). Reprinted by Reprint House International and Haskell.
Men Without Art (1934). New York, Russell & Russell, 1964.

The Lion and the Fox: The Role of the Hero in the Plays of Shakespeare (1927). Available in Methuen paperback, 1966.
The Writer and the Absolute (1952). Never reprinted.

Autobiography and Memoir
Blasting and Bombardiering (1927). Reprinted and available with certain extra material added and certain omissions, Calder & Boyars, London, and University of California Press, 1967.
Rude Assignment (1950). Never reprinted.

The Letters of Wyndham Lewis, ed. W. K. Rose. Methuen, London, and New Directions, Norfolk, Conn., 1963.

Miscellaneous
A Soldier of Humour and Selected Writings, ed. Raymond Rosenthal, Signet Classics, New York and London, 1966. An interesting collection drawn from Lewis's short stories, some of the *Blast* material and other miscellaneous essays and excerpts from books.
Wyndham Lewis: An Anthology of His Prose, ed. E. W. F. Tomlin, Methuen, 1969. Contains large selections from *The Art of Being Ruled*, *Paleface*, *Men Without Art* and a number of Lewis's other prose works.
Wyndham Lewis On Art: Collected writings 1913-1956, ed. Walter Michel and C. J. Fox, Thames & Hudson, London, Funk & Wagnalls, New York, 1970. Extremely valuable collection of Lewis's art criticism and philosophizing.
Wyndham Lewis: Paintings and Drawings, ed. Walter Michel, Thames & Hudson and University of California Press, 1971.

Henry James was once asked, by a young man from Texas named Stark Young, to make some suggestions about how a reader unfamiliar with James's work might best proceed: what particular books would he recommend to read first, second, etc. James replied by compiling alternate lists of five books; I shall do the same for Lewis.

(1) *Blasting and Bombardiering; The Revenge for Love; Time and Western Man* (particularly the first section called 'The Revolutionary Simpleton'); *Self Condemned; Men Without Art.*
(2) *Tarr; Time and Western Man; The Revenge for Love; The Human Age* (Parts 2 and 3); *The Letters of Wyndham Lewis.*

SELECT BIBLIOGRAPHY

BOOKS ABOUT WYNDHAM LEWIS

KENNER, HUGH, *Wyndham Lewis*, Methuen, London, and New Directions, Norfolk, Conn., 1954. Pioneering work on Lewis which makes out a strong case for his greatness as a writer.

PRITCHARD, WILLIAM H., *Wyndham Lewis*, Twayne Publishers, New York, 1968. Selective attempt to see Lewis's work as an imaginative whole.

WAGNER, GEOFFREY, *Wyndham Lewis: A Portrait of the Artist as Enemy*, Routledge & Kegan Paul, London, and Yale University Press, New Haven, 1957. Contains much material pertaining to Lewis's career.

ESSAYS AND REVIEWS

Agenda. The 1969 issue is wholly devoted to Lewis with a number of excellent essays on him. Handsomely illustrated with Lewis's own graphic work.

ALLEN, WALTER, 'Lonely Old Volcano : The Achievement of Wyndham Lewis', *Encounter*, 21 (September, 1963) 63-70. Review article on the publication of Lewis's letters. Good attempt to see the career as a whole.

ELIOT, T. S., 'Wyndham Lewis', *Hudson Review* (Summer, 1957) 167-71. Appreciation written after Lewis died.

HOLLOWAY, JOHN, 'Wyndham Lewis: The Massacre and the Innocents', *The Charted Mirror*, Routledge & Kegan Paul, London, 1960. Perhaps the best single essay on Lewis's insight into modern reality.

LEAVIS, F. R., 'Mr. Eliot, Wyndham Lewis and Lawrence', *Scrutiny* (1934-5) Cambridge University Press, 1963, 184-91. Hostile and lively criticism of Lewis in relation to the other writers.

PRITCHARD, WILLIAM H., 'Lewis and Lawrence', *Agenda*, 1969. Extended comparison of the two writers which answers Leavis's criticism.

SYMONS, JULIAN, 'Meeting Wyndham Lewis', *Critical Occasions*, Hamish Hamilton, London, 1966. Engaging reminiscence.